Alternative Photographic Processes

Alternative Photographic Processes

Crafting Handmade Images

Brady Wilks

Focal Press
Taylor & Francis Group

NEW YORK AND LONDON

First published 2015
by Focal Press
70 Blanchard Road, Suite 402, Burlington, MA 01803
and by Focal Press
2 Park Square, Milton Park, Abingdon, Oxon OX14 4RN

Focal Press is an imprint of the Taylor & Francis Group, an informa business

Notices
Knowledge and best practice in this field are constantly changing. As new research and experience broaden our understanding, changes in research methods, professional practices, or medical treatment may become necessary.

Practitioners and researchers must always rely on their own experience and knowledge in evaluating and using any information, methods, compounds, or experiments described herein. In using such information or methods they should be mindful of their own safety and the safety of others, including parties for whom they have a professional responsibility.

Product or corporate names may be trademarks or registered trademarks, and are used only for identification and explanation without intent to infringe.

Library of Congress Cataloging in Publication Data
Wilks, Brady.
Alternative photographic processes : evidence of the photographer's hand / by Brady Wilks.
pages cm
Includes bibliographical references and index.
ISBN 978-1-138-80868-3 (pbk.) -- ISBN 978-1-138-80866-9 (hardback) -- ISBN 978-1-315-75054-5 (ebook) 1. Photography--Processing.
I. Title.
TR287.W55 2015
778.6'6--dc23
2014039587

ISBN: 978-1-138-80868-3 (pbk)
ISBN: 978-1-138-80866-9 (hbk)
ISBN: 978-1-315-75054-5 (ebk)

Typeset in Avenir by
Servis Filmsetting Ltd, Stockport, Cheshire
Printed and bound in India by Replika Press Pvt. Ltd.

To my wife Laurie and son Soren, for their inspiration, love and support.

Contents

Introduction

By Jill Enfield

So you think alternative photography is another name for historical techniques? Think again, because Brady Wilks is here to tell you otherwise. Finally, a book about ALTERNATIVE ways to combine all aspects of photography and printmaking. From simple suggestions, such as holding a piece of scratched glass in front of your lens, to using scanners as cameras, or using digital positives with collodion plates, you will see that with a little thought and imagination, analog and digital capture can be combined and manipulated with or without the use of editing software.

Brady fell in love with the notion of showing the artist's hand in his work and set out to not only educate himself on how best to do different methods, but to help to educate others in these processes. I know first hand that Brady was not shy in contacting people who he wanted to learn from. Emails would arrive with questions followed by phone calls and more emails with attachments of work he had done. He wanted to make sure he not only could do the processes but also could easily explain them to others. Brady certainly has succeeded.

Some of these techniques are so simple that when you read through Wilks' book, you will probably say to yourself that you should have thought of these things on your own, but that is where this book comes in! It is jam-packed with suggestions to spark your imagination, break out of an artist's block, or share with your students. Really fun stuff!

Historical techniques have steadily been gaining in popularity since the 1970s and along with that came many books on the subject. Wilks felt that there was no reason to repeat what had already been done perfectly well, so he set out to put together a book on basic processes and variations; a supplemental book that should be included in a photographer's arsenal of books. He mentions throughout where to find exact directions, if the reader needs to study further. However, if an artist is looking for ideas on how to expand their toolbox, the information is all here. The mix of how-tos and beautiful examples is put together simply and effectively, so that you can thumb through and find examples and explanations of how to include the processes in your own work. As an educator myself, I found many processes to include in my classes that I had never thought of before, such as using your cell phone along with an enlarger to make a print. I can't wait to revise my syllabi in the coming year.

Photographers that have mostly concentrated on historical techniques and darkroom work will appreciate the idea of incorporating the historical with digital, and those that have concentrated on mostly digital will have fun discovering new ways of using technology.

Brady describes himself as an "artist and educator," and he certainly educates in this book.

Jill Enfield

About This Book

The photographer's hand is seldom seen, especially when measuring it against the endless ocean of images in our current digital era. Many of the photographs being made look alike due to the number of images being created and the camera format, digital latitude, and basic filters commonly used. Artists are looking for alternatives to popular methods to help define their own unique creative voice. Not solely for the sake of being different, but also for the resolve that comes from crafting an image by hand. There are a number of books and teachers covering historical and alternative photographic processes with great resources. However, this book emphasizes specific methods before and after capture. It provides simple instruction and working examples of various alternatives to alternative processes as well as techniques for artists to explore and define their own working methods for creating handmade art.

This book is written to supplement the basics and provide students, artists, and educators with additional alternatives in photographic process art. It even supports artists working in mixed media, printmaking, and other mediums, as many of them are cross-platform. Readers will learn how to accomplish various techniques with sections on troubleshooting process flaws, contemporary artist examples, and additional resources. Each chapter will thoroughly cover variations of each process and how to control process characteristics to accentuate image-making. Additionally, each chapter will include examples of artists using the various mediums and explanations as to why they have selected their specific techniques.

HOW TO USE THIS BOOK

This book is designed for a fairly broad spectrum of artists with different skill levels. There are tutorials to allow anyone at any skill level to follow along. There are ideas and alternatives to popular techniques for beginners and practiced artists alike. Students, hobbyists, artists, and educators will be able to use this book as a way to explore the many variations and alternatives in image-making. Some processes require previous knowledge of associated chemistry and working methods.

It is suggested that all readers find the process that interests them and read all of the content of that chapter, further researching it online or from other resources before starting. It is the responsibility of the reader to take all necessary precautions in the handling and use of their materials with all processes. Some chemicals are very dangerous and even lethal, but if the user respects the materials and follows the Material Data Safety Sheets (MSDS) available online, they will be able to command the materials safely to make great art. Not all processes are dangerous but a general respect for the materials should always be practiced.

Acknowledgements

This book is the product of so many people and their contributions to the project. There are hundreds of people I could write a paragraph for, but a few sentences are all I can afford.

Thank you, Deirdre Byrne: Acquisition Editor, Sloane Stinson: Associate Marketing Manager, Anna Valutkevich: Editorial Assistant, Sian Cahill: Production Editorial Manager UK, Denise Power: Production Editor, Mat Willis: Design Team/Cover and the entire Focal Press team who worked on this project.

Thank you to my wife Laurie and son Soren, who have been an inspiration, supportive and patient.

Thank you to my mother Sue, for her undying love of the outdoors and her persistent encouragement to take me out into nature and, with my father's help, to provide me with a foundation for the arts.

Dr. Harry Stavros, thank you for saving my life by providing me with the space to learn and to experience the arts during a hard time of my life.

Henry Horenstein, thank you for your mentoring, continued support, and encouragement to work on this book.

Jill Enfield, thank you for your encouragement with this book and willingness to share your knowledge and work with others so openly. You are a reflection of just how supportive our community can be.

Dan Estabrook, thank you for your dedicated push to get me through a very difficult time. Without you and your support I would be miles behind in my own work. You are one of the greatest and most intelligent artists I know.

Mark Osterman, thank you for your seemingly endless knowledge base and, more important, your willingness to share. I treasure the workshops I have had and hope to have many more.

France Scully Osterman, thank you for your insight and willingness to share much more than process-talk. I attribute much of my success to the support you have given me.

Thank you Nick Brandreth for your help as tech editor and for keeping me on track with the book and its contents. You are always generous with your time and it is much appreciated.

Thank you to my friends Joe Mills and Edward Bateman who challenge me and support me in surprising and unpredictable ways. I can only hope I do the same. I cherish our friendship.

A special thank you to David Arnold, Maureen Delaney, Jan Faul, Marico Fayre, Tamara Hubbard, Mark Malloy, Will Mosgrove, Trace Nichols, Adrienne Pao, Barbara Scheide, and Lisa Sheirer, who gave me incredible opportunities to grow and learn after moving from coast to coast. You supported me in a very important time and continue to do so.

I am extremely grateful to all of the artists and contributors who have given me so much more than an image and a release form. Their work is a true example of what is possible in art and I am thankful for their patience and willingness to share with readers their art and other insights. I wish there was room to include more images and of course more artists as you all have made this a much stronger project.

Brady Wilks Guardians of the Underground, Acrylic Gel Lift / Transfer on Wood

1

CHAPTER 1

Capture Techniques

1.1 Introduction

With today's technology, it is easy to make photographs quickly and with great convenience. Some photographers, however, choose not to go with the easy route and instead spend time manipulating the image at time of capture.

With pre-capture manipulation comes an idealized gesture of spending time with the photograph. The more time the artist spends with the subject, the more they get to know it and the more resolved the image becomes. This is not conducive to the type of photographer that wants to shoot quickly or from the hip. Even with preconceived ideas, it is a slower process and lends itself to those that tend to work a little slower. This is further emphasized with the choice of manipulations and other decisions at time of capture.

Pre-capture manipulation can be done in a number of ways, such as distressing lenses, filters, screens, glass, lens mods, etc. Instead of shooting first and editing your image in post, you may choose one of the following processes in this chapter to add more depth and dimension to your image right from the start.

What better way to connect to your subject matter than to spend more time with it from the beginning? Through this book you will learn a number of basic techniques and how to expand on them so that you may choose the best solution for your creative workflow, be it fast or slow.

1.2 Glass Manipulation

One of the amazing things about optics in relationship to lenses is how forgiving any damaged front lens element, filter, or glass can be. You can still attain great looking images with little to no effect, even with scratches or broken glass. The trick when using distressed materials is to control its effect by adjusting the aperture (increasing the depth of field) and the distance that the distressed material is from the lens or focal plane.

NOTE

· · · · · · · · · · · · · · · · · ·

Glass manipulations include destructive and non-destructive methods. Before distressing or damaging lenses and filters, try practicing or even commit to the idea of using sheets of glass, which can be held right in front of your lens. The use of a tripod with a trigger is suggested so that the artist can hold and manipulate the glass with ease.

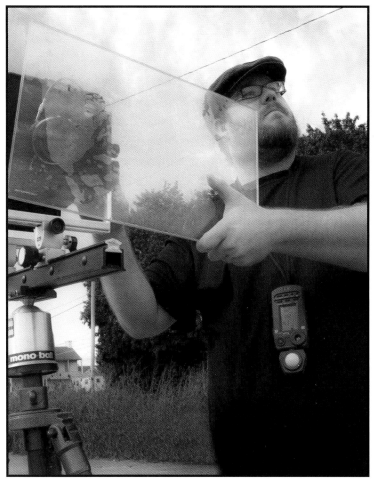

Figure 1.1 Brady Wilks using distorted glass plates held in front of a view camera. Photo by Palma Brozzetti

If purchasing glass from a hardware store or frame shop, check to see if they have beveled or finished edge glass. If not, be very careful when handling the glass. Use a sharpening stone to rub along the edges of the glass on both sides to take off the sharp edge. Wear goggles, edge it while holding it over the trash to collect the dust and be careful of the sharp glass edge and dust. Glass edges, shards, and dust can be dangerous: you don't want them in your eyes or lungs. Use a soft brush or natural fiber paintbrush to remove the dust from the glass surface before proceeding to your chosen effect. This kind of glass handling is borrowed from artists using the technique for wet plate collodion positives and negatives on glass.

When using a wide-open aperture (f/2.8), you might see a very soft distortion or you may not see much of the distressing at all. Stopping down your aperture toward f/11 through f/22 and beyond will eventually bring artifacts closer into focus. With experimentation, you will quickly learn which aperture adjustment looks best for your particular method after capture.

Another amazing thing about distressing optics is the artist's ability to let direct light affect the image through the distortions, blocking, focusing, reflecting, and refracting light. Depending on the distortions the artist chooses, it will change the direction of the light, focus the light, block or even diffuse the light in various ways. For example, if you are using a distressed filter full of chips, your aperture is set to f/16 and there is sunlight directly hitting the front of the glass element, all sorts of refractions may occur depending on the characteristics of the damaged areas and how they bend the light.

You can purchase some filter effects already premade, such as fog, soft focus, and other light modifiers, but making your own gives you control to make it exactly as you want. It can also be much more cost-effective than purchasing specialty filters. Lastly, there may be a personal satisfaction knowing that your image-making is so in-depth that you are crafting tools as well.

FILTER STACKING

Filter stacking is done by taking multiple filters and stacking them together. An artist may play with a number of different combinations, such as color, effects, or both. For example, using a combination of warming filters not only changes the color but forces the light to pass through an increased amount of glass and can begin to start various distortions.

Polarizers are used to block certain reflections. Using two circular polarizers stacked together opposite one another and rotated will vary the degree at which light will pass. You can

Figure 1.2 Stacking similar warming filters

Figure 1.3 Stacking similar cooling filters

Figure 1.4a Stacked polarizing filters: before conversion to black and white

Figure 1.4b Stacked polarizing filters: after conversion to black and white

rotate the filters to the extent that only purple light is able to pass through resulting in a very dark image.

FILTER AND GLASS DISTRESSING

Scratching: scratching is done with things like diamond tools, electric etchers, and other elements strong enough to score

SPECIAL NOTE

Damaging the glass of filters is irreversible, it is important not to try any of the following directly on the glass of your lens. Use sheet glass and experiment with making your own filters as opposed to working on your original equipment.

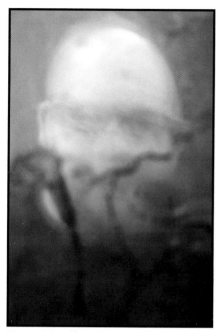

Figure 1.5 Self-portrait made using broken and distressed glass held in front of the lens

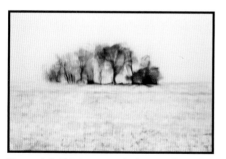

Figure 1.6 This image, titled *Seen Through a Veil of Tears*, was produced by using two sheets of glass with water sandwiched between the sheets and water on the face of the glass

the surface of glass. They may be seemingly random, precise and calculated, or simple patterns to create the various effects.

Broken glass layers: using broken glass and epoxy or other transparent glues can allow you to make mosaics of shards distorting the image in a number of ways. This is greatly dramatized by the size of the shards, their location, the thickness of the glue in between, and the thickness of the glass. One method is to use a solid piece of glass and attach broken pieces of glass with glue around the edges so that there is some clarity in the center.

Sanding: various sandpapers can provide different scrape patterns and intensities, especially true depending on the type of material you are using, as well as the pressure, speed, direction, and intensity of the sanding. Using a power sander, such as an orbital sander, can produce sanded distortions around the edges of glass quickly.

Frosting: using special wet pastes with various grits is not only a great method to create frosted edges or fogging filters, but it is also what some artists use to make their own ground glass for view cameras.

Gradient marks: this can be applied for a number of effects. The idea is that you change the intensity or frequency of the distortion gradually from edge to center. For example, you can make a soft focus filter with a clear center. Leaving the center untouched and gradually changing the intensity of the pressure used with paste and/or various grits. The more you rub, the frostier it gets.

Liquid suspension: this process requires two sheets of glass (big enough to hold and still cover your lens area) and some kind of fluid. Lay one sheet flat and pour on a little bit of water, tea, oil, or other fluid substance that is easily cleaned. Then place the other sheet on top. This suspends the fluid

between the two sheets of glass and makes various distortions depending on the solution used. Start with very little so it doesn't run out of the sides.

Smudging: if you don't have a glass sheet or if you don't want to damage filters or lenses, you can use a number of materials to smudge onto a filter as a way to create effects in a non-volatile way, saving the glass and reusing it for other things. Grease, Crisco, butter, and a number of other smudgy materials can be used, just be sure it is something you can clean off and don't leave anything on that can go rancid or spoil. Never apply it directly to your lens. Use sheet glass or old UV filters.

Breath/fog: this is achieved by simply fogging the front element with a deep breath and wide-open mouth really close to the glass, like someone cleaning their glasses. This works better in certain atmospheric conditions where the condensed moisture on the glass takes a while to evaporate.

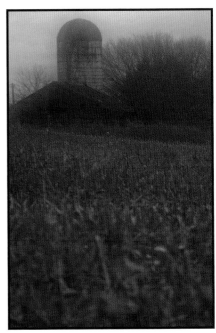

Figure 1.7 This image was made with a UV filter that was smudged

1.3 Veils and Obscuring

Glass is great but there are a dozen other things to consider if you want to manipulate your image at time of capture. The following lists, with descriptions, offer other alternatives to working with glass, filters, and lenses directly.

SCREENS AND SCREEN STACKING

Image-making with screens provides an aesthetic few others can. Screens obscure through hundreds of little fibers, be they fabric, synthetic, or metal. There are different kinds of materials that can act as a screen. Some screens come premade, such as those made as anti-glare filters for computer monitors and displays. Screen printing mesh, window screening made of

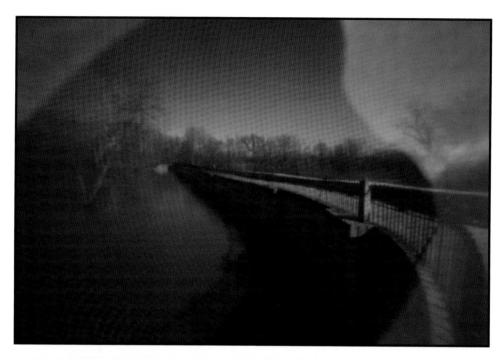

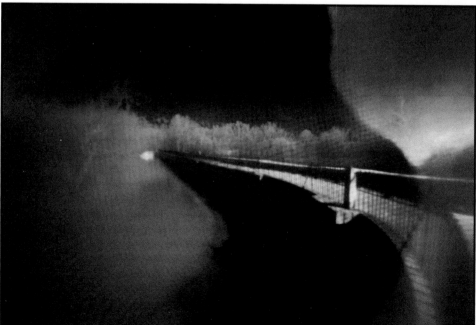

Figure 1.8 & 1.9 This original capture was created by using two antiglare computer screen filters held at different angles. The bright area to the right is where the sun was hitting the screen directly, altering the perceived brightness of the image in that area. The image below was simply processed using a black and white conversion software to emulate infrared film, giving a dark sky and emphasized highlights

vinyl, safety mesh for baby cribs, mosquito net, and a dozen other materials can be used, each with their own aesthetic.

There are two primary things to consider here. Do you want the screen to act as a blurry veil only adding a little atmosphere or interruption of the light? Or do you want the screen to become a more apparent transformative tool? The more material you stack and alter in direction, the more of an effect the material will have on obscuring your image.

Want to add a twist to your screen imaging? Allow the sun or other light source to illuminate part of the screen. You will achieve dramatic differences between the parts of the image where the light passes through the screen, contrasted against the part where light passes through the illuminated portion of the screen. Figure 1.8 is an example from an experimental session with screens that was then converted to black and white, (Figure 1.9).

PLASTIC WRAP AND BURNING

Similar to glass, plastic wrap can be distorted and distressed but in a very different way. Using plastic wrap gives a different look than distressed glass does. The easiest way to work with plastic wrap is to build a small frame or use an existing thin border art frame and stretch the plastic wrap over the edges. In order to make the plastic wrap tight, hold it in place using tape. If your frame is large enough, you may distress multiple areas to vary your images from exposure to exposure. This, of course, is held right in front of your lens so the frame must be large enough so that it is not seen while holding it.

Ripping holes, burning holes, smudging, and bending the plastic wrap are just a few examples of where you can start with your experimentation. You may also use multiple layers of plastic wrap to encapsulate debris or translucent materials. Just keep in mind that after you experiment, you then make

decisions to select the process that best supports your image-making and art.

TRANSPARENCY FILM, ACRYLIC SHEETING, AND FRESNEL SCREENS

These materials, and others like them, can be used without building a framework; they should be rigid enough on their own. Be sure that you have a sheet large enough to hold out of view. It is the same as other processes. You may burn, scratch, and distress them in a number of ways. Start small so that you don't waste materials.

1.4 Lens and Camera Modifications

There are many ways to work outside of the common characteristics of digital format and traditional format frames. You can simply try cameras you have never tried before such as a medium format camera with a 6cm by 12cm frame, or you can modify and make your own lenses and cameras. Depending on your lens' manufacturer, focal length, and other variables, you can use antique lenses on modern DSLRs. You can also use your DSLR as a digital back attached to a view camera and a number of other configurations. The following section explores ways to modify, alter, and combine various processes.

Much like directly altering the glass or lens elements, there are several ways to manipulate your imagery at time of capture through the use of lens modifications. These mods tend to retain the original condition of the lens or other materials as opposed to damaging or distressing them directly. There is little damage done here with the exception of having to drill or

glue certain configurations. Not all lenses and cameras fit, and there certainly isn't an adapter for every possible combination, but there are ways around that with extension tubes.

If you have or are looking for antique lenses with various properties, you can use adapters for different camera mounts to intermingle brands and periods. For example, a popular lens to use with modern DSLRs is the pre-WWII Zeiss Jena Biotar 7.5cm f/1.5. This lens was made with various mounts for Leica, Exakta, and others but you can find a match that allows you to use this lens with a more modern film or digital camera. With known focal lengths (distance from the back of the lens to the film or capture plane) you may use the lens in homemade cameras or other configurations.

An easy modular approach to lens modification is through use of a view camera. By making your own lens boards, you can mount just about any lens and adjust for its specific focal length (distance to film plane). Bag bellows can be used for wide angle lenses or lenses that require the back of the lens to be very close to the film plane. There are also cameras with accordion bellows and bed extensions for lenses that require a longer distance to the film plane, or macro work.

The bellows camera is a great platform for the use of brass lenses. The focal distance and lens coverage of many old brass lenses require the lens to be farther away than most 35mm cameras.

There are modern bellows cameras that can be used in combination with custom lens boards and a number of lenses. Film holders can be converted for use with wet plate collodion, but film backs, digital backs, and even homemade scanner backs can all be used with the right mods.

You may also choose to use some lenses with a 35mm SLR/DSLR or medium format camera through use of extension tubes and

some engineering. Salvaged lenses from older cameras of odd sizes work great as well. One of the main aesthetic choices for using these found lenses are in relationship to coverage. A lens will project a spherical version of the source. In the center of the projected image it may be sharp with little to no obvious distortions. Toward the edges and outside of the center, the light begins to fall off and the distortions come into view.

If you use a lens made for a 5×7 view camera on an 8×10 you will have coverage issues, something that many artists look for as an aesthetic choice.

BUILD YOUR OWN

Much like Holga mods, there are endless varieties of homemade lenses. Any glass lens, including a simple magnifying glass, can be used to make your own camera lens. The goal is to determine its focal length and approximate coverage, and marry that to a suitable camera or capture device.

Lenses can be made from copper tubing, cardboard, tape rolls, extension tubes, plumbing, PVC, and a number of other materials. Borrowing the traditions of camera obscura, you can get an idea of a lens' focal length by bringing it close to a wall that is perpendicular to a window or light source coming through the lens. Approximate the distance between the projected image and the lens and you will know about where you should start in terms of construction. The next trick is constructing a lens in a way that can be focused. I've made some using shade bellows or old enlarger bellows on a rail system. The lens should have a control that allows you to physically move it closer or farther away from the film or capture plane. I won't overextend the use of this book by listing a number of how-tos when there are too many to be found online already, but by knowing the principles involved in how it works, you can find your materials and experiment, devising your own methods or choosing to follow a how-to online later on.

CAMERA MODS

Holga Mods

There is a solid community of photographers using toy and novelty cameras for specific aesthetic reasons. Holga is one of the popular choices and there is a community of Holga owners that go on to modify their cameras in various ways. Some of the basic mods are made to improve aperture, to add a cable release, fix light leaks, etc. There are more advanced modifications where artists deconstruct and reconstruct multiple cameras into one, or upgrade lenses, sometimes permanently attaching medium format lenses onto the camera. There are panoramic, stereo, and a number of other Holgas and toy cameras in various configurations. You can buy them premade or modify them yourself.

There are great resources for doing this already in place so this book will not cover detailed instructions on how-to. A simple Internet search will lead you down a long road of how-tos and all the variations. Just know that there are endless possibilities and configurations with not only Holga but any camera/lens combination. You can try to be the engineer yourself, follow instructions online, or purchase cameras from companies providing premade modified cameras.

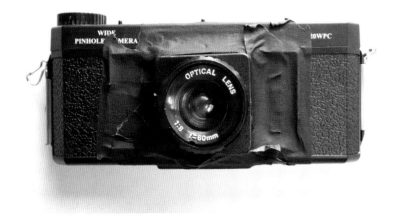

Figure 1.10 This camera was modified by Geoff Delanoy before the same option was commercially available for purchase. He also boiled and manipulated his Holga lenses for various aesthetics

Figure 1.11 This work was produced by Geoff Delanoy using the camera seen in Figure 1.10

HOMEMADE

Another type of mod is simply to marry different formats and lenses from various manufacturers and use what you have around the house and garage to make unique cameras. Some people refer to it as *Frankensteining* or simply building cameras from found objects and camera parts. There are many artists with their own modified or created cameras. Great searchable examples include the work of Taiyo Onorato, Nico Krebs, and

Miroslav Tichý, all making use of various materials, sometimes including animal parts and other found objects. Searching their work will give you an idea of what's possible and hopefully be the catalyst to devising your own methods and making your own cameras.

1.5 Scanner-Based Image-Making

Using scanners as image capture devices, including camerabacks, can be used to make imagery in a way that no other process can. Because a scanner receives the image and essentially paints the image line by line, there is a unique set of characteristics that occur when any of the subject matter moves or is changed.

A simple way to start using scanners for image capture is to model the aesthetics used with photograms. An artist may choose to use found objects and other materials to make arrangements on the glass. There are differences between scanning them as a document or as a transparency. When using a setting to scan transparency material such as film negatives, a light projects through the objects. Not all scanners have this capability. There are also major differences in using different colored backgrounds or none at all. Additionally, the dimensionality of your chosen objects will affect the image differently. Let's take a look at variations in still subjects.

USING A SCANNER AS A CAMERA-BACK

There are many differences between various scanner brands and how they scan the light. Some scanners will need to be modified more than others. Generally speaking, you will need

Figure 1.12 Scanning while moving the object

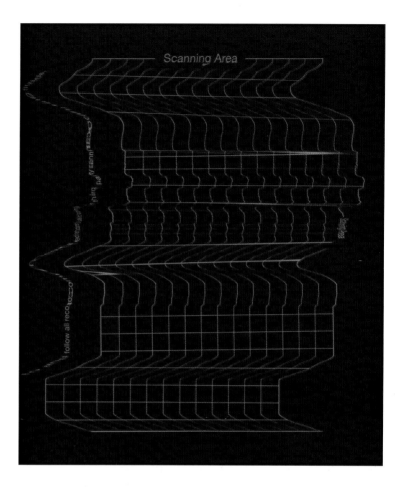

to remove the lamp that illuminates as this can wash out any projected light from a lens. A favored scanner to use is one that is powered by a USB cable. This means you don't need to be in a studio to use the scanner back. You can tether and get power from a laptop in the field. A popular choice can be found within the Canon LIDE series of scanners.

There is not enough space to cover an in-depth how-to on the modification of different scanners. However, there are several great resources online and with a simple search you can find a method that matches your scanner.

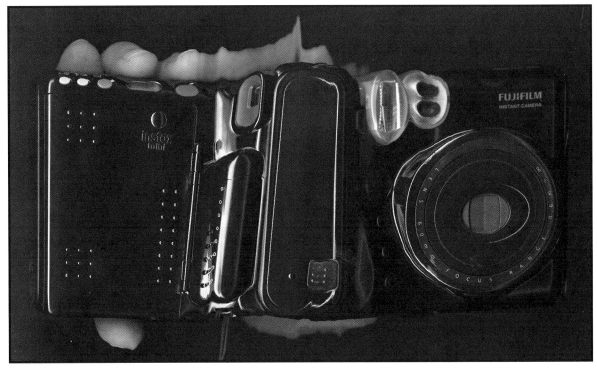

Figure 1.13 Scanning while rotating to see all sides of an object

How a scanner back captures movement

Dan Herrera has one of the best examples of a scanner back mini-series. Each still shows the different characteristics of movement captured, depending on the direction of the scan, the position of the subject, and the subject's movement in relation to the movements and direction of the scanner's head.

Vertical: If the scanner is moving vertically during the scan, any horizontal movement would translate as a zigzag pattern from the original position of the scan.

Horizontal: If the scanner is moving horizontally during the scan, any horizontal movement will stretch the moving subject, elongating the figure in the scanned area or, if held still in sections, the scan can reveal all sides of a subject, first the back,

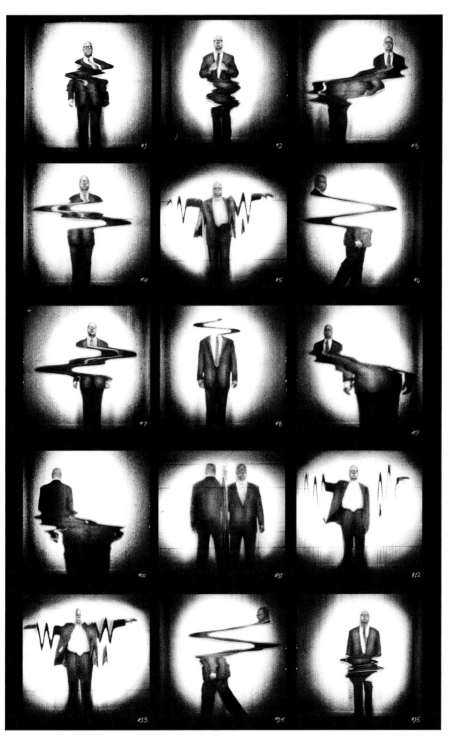

Figure 1.14 A collection of images from Dan Herrera's *Están de una Herencia Extraña* series, making use of a scanner to capture images

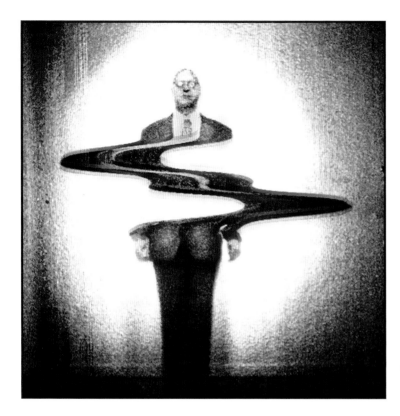

Figure 1.15 Plate number 07 from Dan Herrera's *Están de una Herencia Extraña* series

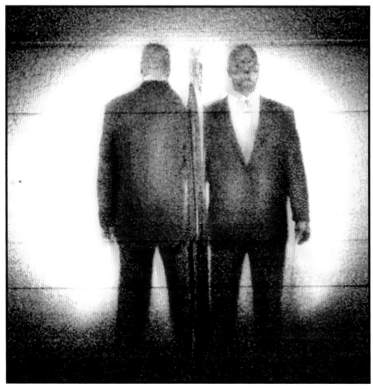

Figure 1.16 Plate number 11 from Dan Herrera's *Están de una Herencia Extraña* series

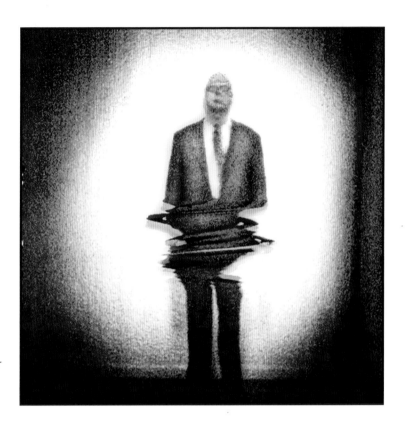

Figure 1.17 Plate number 15 from Dan Herrera's *Están de una Herencia Extraña* series

then side, then front, by only moving once the scanner has passed that section.

Twisting: if the scanner is moving vertically during the scan, any twisting a subject does will show the various sides as a spiral. If the subject is wider when facing front and narrower when sideways, the spiral will also distort according to those dimensions.

2

Film and Transparency Manipulation for Wet Lab Processes and Scanning

NOTE

· · · · · · · · · · · · · · · ·

If you are printing your own images on inkjet transparency film such as Pictorico, you will need to familiarize yourself with the differences between positives, negatives, densities, and color tones, and how that affects your image with each process. For example, if I am creating a negative to be used with something like cyanotypes, I will certainly have to adjust my image in Photoshop using specific tools such as the adjustment titled curves or perhaps another titled level. If I make this negative specifically for cyanotypes, it will most certainly not work for something like wet plate collodion contact positive, because it is in reverse. Chances are it won't produce great prints with any other process.

When working with film negatives, film positives, or inkjet transparencies, an artist can incorporate a number of after-capture techniques to alter and manipulate the images physically. These techniques can be used for enlargements and contact prints, for wet lab processes, or for use with a scanner. If you choose not to use film, there are many brands of overhead transparency film. Pictorico is a popular brand carried at many photography stores such as Freestyle, B&H Photo Video, and many others.

2.1 Film and Transparency Manipulation

SPLICING

This is a process that makes use of multiple exposures or images on transparency film that are cut up and spliced together in order to make a larger image or add a different narrative and aesthetic.

When working with film or digital exposures, you will want to photograph or print multiple exposures of the same thing. Not

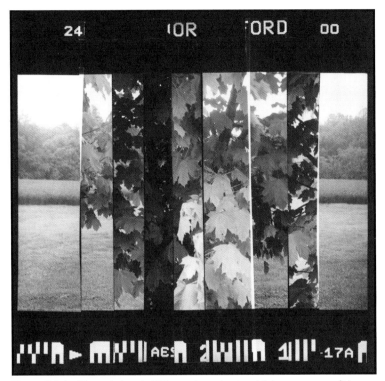

Figure 2.1 In this work, Laurie Wilks made and cut multiple exposures of the same subject and spliced them together before enlargement

only will this allow you to experiment and make mistakes but you will be able to add an illustrative narrative. There are many options when making multiple exposures, such as multiple angles, multiple subject positions, and other differences. These subtle changes can be used collectively by cutting up various portions and aligning them in different ways to make a larger negative or grander narrative.

Essentially you will need something to cut the film, like a pair of scissors, a razor blade, or hobby knife. You can use blank transparency film as a carrier to be used with tapes or adhesives when assembling the larger image. Note, that different tapes and adhesives will affect your image when making enlargements or scans. For example, if you are splicing

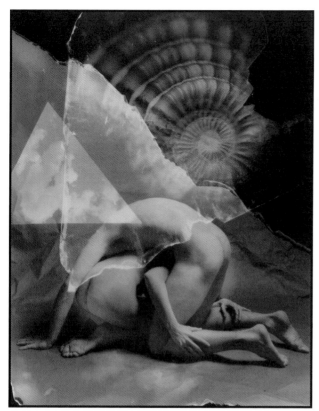

Figure 2.2 Vincent Serbin, *Negative Collage no 14*

Figure 2.3 Vincent Serbin, *The Power of Imagination*

film negatives and you use clear tape, the edges of the tape will come out white, because it is blocking the light, and the areas inside the tape might be a bit lighter than the rest of your image because the light has to travel through more material. If you use tapes that are opaque, their thickness and density will block the light in various ways. Make tests before assembling the real thing.

Vincent Serbin's work is a great example of using multiple exposures combined to make a larger image or change the narrative of an image. He also makes use of other aesthetics including the use of transparent materials such as tape and physical alterations.

CUTOUT AND HOLE-PUNCHING

There are a number of tools that will allow you to cut out certain parts of your image, punch holes, or even stab holes into your film. Depending on the process, this can produce a black area when scanning a negative, or a white area when scanning a transparency positive.

A standard hole-punch will produce a very large hole in a 35mm film negative, but might be a great size for a larger inkjet transparency film negative for use with a contact print. For small holes consider using a Japanese style screw-hole-punch. Their action produces a very clean hole and it works much like an antique reciprocating spiral drive push drill. It comes with multiple bits for different hole sizes. This tool is used by many book artists and might be found in stores that carry book arts materials, or websites catering to those artists working with book arts and associated supplies. An alternative to this expense is a series of needles. Needles can make nice holes, but one of the problems is that they don't really remove the excess film like the screw-hole-punch does. It is not that big of an issue if you are using the film to project for an enlargement, but it might limit the ability for a clean contact.

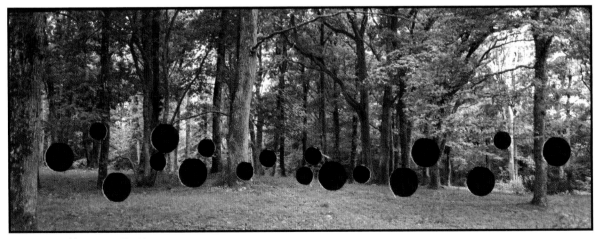

Figure 2.4 Aliki Braine, *The Hunt*

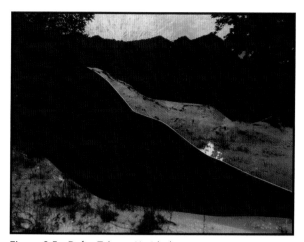

Figure 2.5a Dafna Talmor, *Untitled*

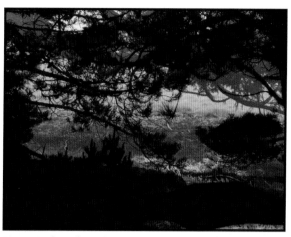

Figure 2.5b Dafna Talmor, *Untitled*

A hobby knife or razor would be a likely tool for working with cutout techniques. Cutting out areas of a film negative will produce a black area when enlarged or scanned. If scanning a positive transparency, the cut out area will be white.

SCRATCHING AND DRAWING

When scratching or drawing on your negatives, you will create different effects with different materials. For example, if you use a needle to scratch areas of the negative, it will produce different results than if you use a permanent marker or other color markers. Some of the tools and materials you can use include sandpaper, steel wool, needles, blades, sharp tip objects, translucent markers, and permanent markers.

The hand image in Figure 2.6 was made starting with a scanner-gram and was then printed to inkjet transparency film. It was then drawn on with a black marker. Wherever the black marker exists, the light will not pass through, thus producing no exposure of the silver in the wet plate collodion positive. If no silver is produced and your substrate is black, then there will be no silver on top of the black, resulting in a dark area.

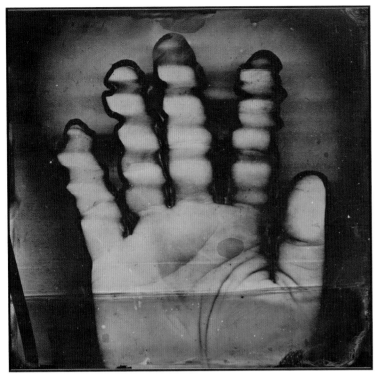

Figure 2.6 Brady Wilks, *Untitled, wet plate collodion positive on black glass made by contact printing with a hand colored and distressed inkjet transparency positive.*

BURNING

You can cautiously distort and burn your film in a number of ways to add various effects. Be careful of your materials and the potentially harmful fumes that might be produced while burning. Try working carefully outdoors with plenty of ventilation and do not inhale the fumes. Follow the safety guidelines of your materials whether you are using an alcohol lamp, lighter, matches, or any other tool.

OTHER FILM ALTERATIONS

There are so many more processes that we should at least mention. Many of the instructions can be found online or in other book resources. Suggested books, workshops, and

SPECIAL NOTE

The trick with any of these processes is to make multiple exposures ahead of time so that, should you go too far in your manipulations, you can use a back up or two. Most of the alterations are permanent.

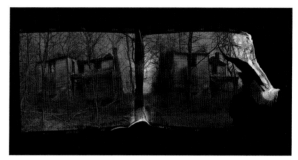

Figure 2.7 Brady Wilks, *Burned Film Negative*

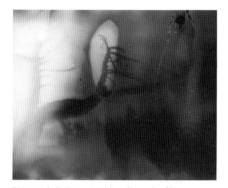

Figure 2.8 Peter Wiklund used a film soup technique for these serendipitous effects

teachers are mentioned throughout the book and can be found compiled in the Resources section.

Film Soup

This is a commonly used name for a number of processes in which you soak your film in various chemicals or baths, such as ammonia detergent, or place it in a washing machine and possibly set it to run a full cycle, among other soup suggestions. The idea is that the soap and water alters the film in different ways, either before or after you expose your images. One careful consideration with this process is to allow the film to dry. In order to allow the film to dry you must let it sit in a warm dry place, over several days perhaps, or you must remove the film in a totally dark room and hang it to dry before loading it into the camera. This must be done in absolute darkness or you will fog your film. If you do not have access to a darkroom or film loading room, you can try to convert a closet into a darkroom and hang it up to dry but you will need to figure out a way to enter and exit without allowing light in, unless you feel like sitting in the closet for a few hours while it dries. After it dries you can either rewind it and load it into a camera for shooting or, if it is already exposed, you may load it into a development tank for processing.

Oven-Baking

This process requires you to bake exposed rolls of film in an oven on a very low setting so that nothing melts. Some

resources suggest baking it at around 100 degrees for a few minutes, and others suggest both cooler and warmer settings and various times. All ovens are different and caution must be used so that you don't damage your oven or your images or start a fire. You only need to heat up the film slightly, like as would occur on a summer day. You do not want it hot enough to melt it or cause damage from fire or otherwise. Leaving your film in your car window for a few summer days could also do the trick. If done correctly it makes your images look pale when processed.

FILM DEVELOPING ALTERNATIVES

Developing film at home without a darkroom is easily done with the right tools. You will need the proper chemistry, a changing bag or light-proof closet for loading film, a reel with a processing tank, a few containers to hold the various chemicals, running water, and drains that run to a collection bottle or city sewer.

It is not advised to pour any chemicals down your drain if you are on a well and/or septic system. Use a sink that enables you to connect the drain to a collection bottle and dispose of the used chemicals properly elsewhere. Some artists build studios with a special collection and processing tanks that filter and neutralize many of the chemicals. The silver from traditional photographic processes can be recovered from the fixer and recycled as well.

If you would like more info on traditional film processes and are interested in setting up a darkroom, there are lots of great resources including Henry Horenstein's *Black and White Photography: A Basic Manual* in its third revised edition. There are a number of other good books but this is the one I learned from years ago and the one I prefer to teach from now for basic and traditional darkroom methods.

Figure 2.9 This Polaroid film work was made using heat by Peter Wiklund

If you do not want to use traditional film development chemicals, you can use the same tools with alternatives to traditional chemicals. One process uses Tylenol and other materials to make something similar to a popular black and white developer originally produced by AGFA called Rodinal.

Another process uses coffee and Vitamin-C, sometimes referred to as Caffenol. There are many Caffenol recipes found online to best suit various film brands and film speeds. A basic formula to start with when using an ISO 100 speed film such as TMax 100 contains the following ingredients:

1. Instant coffee: a strong yet inexpensive and generic brand of instant coffee.
2. Pure Vitamin-C: also known as ascorbic acid crystals. Vitamin-C pills might not work the same due to the other ingredients found in various brands. For example, some pills can contain stearic acid, sodium metabisulphite, microcrystalline cellulose, maize starch, talc, or magnesium stearate. Each brand and type has different combinations of some of the ingredients listed. This is why pure ascorbic acid crystals are preferred.
3. Sodium carbonate: white powder also known as washing soda.
4. Distilled water: some people have used tap water but who knows what your tap water has in it. Make a habit to use distilled water for all recipes in all processes except when chlorinated water is needed for very specific processes to remove excess silver or other specific circumstances.

Use a clean container that can hold a bit more than a single liter of liquid and dissolve 52 grams of Sodium Carbonate into 1 liter of distilled water. Next, mix in 16 grams of Vitamin-C then mix in and dissolve 40 grams of instant coffee crystals.

If your developer is around 68–70 degrees you will develop for a total of 14–15 minutes. The warmer the developer, the shorter

SPECIAL NOTE
.

Resources such as the Caffenol Cookbook, caffenol. blogspot.com, caffenol.org, and digitaltruth.com have lots of recipes and are the go-to resources for at-home development recipes that rival many commercially available products. There are recipes that have been developed and tweaked for use with very specific film and to achieve specific effects.

your developing time. General practice starts development with 30–60 seconds of agitation and then 10 seconds of agitation every 30 seconds for the duration. Everyone has different suggestions based on developer/film types, but the above mentioned guidelines should work fine with TMax 100. Try not to over agitate or agitate too violently. Gentle swirling and hand-over-hand rotation will work great, but be sure to give the canister a good tap or two after agitation. This should release any bubbles that may stick to the film. If a bubble is on the surface of the film, then the chemistry is not able to work on that area and will result in a different look.

After the appropriate development time, you will need to stop the development process with a long water rinse or stop bath, then fix using sodium thiosulphate or a commercially made fixer for around 5 minutes. Again, for those of you unfamiliar with traditional wet lab processes and chemistry, refer to the previously suggested resources.

WETTING TRANSPARENCY FILM

If you have ever used transparency film or overhead projection film that is made for use with inkjet printers, you may have discovered that the side that receives the media is not only delicate but gets damaged when in contact with water. This, of course, can be used creatively to achieve various effects. Spraying it with mist, using solvents, or using water around the edges to produce splotches in the image are just a few examples of possible manipulations.

2.2 Scanning

After manipulating your film negatives, positives, and inkjet transparencies alike, it is time to scan them. That is, of course, if you are not using them in the darkroom to make enlargements

or contact prints. Scanning requires some basic understanding of computers and associated software. For details you will want to refer to the manuals provided with your products. Generally, you will need a computer, a scanner capable of backlit transparency scanning, software for capturing your image, and software for editing your images.

There are many good scanners and computers available but here is one possible combination that produces good results. An up-to-date Mac or PC computer, an Epson V750 flatbed scanner, Silverlight scanning software (usually provided with the scanner), and Photoshop or the current LightRoom made by Adobe. There are cheaper and even free options for capturing and editing images as well.

2.3 Inkjet Transparency Film and Processes

Here is a short list of alternative processes for potential use with inkjet transparency film. It does not make sense to provide instruction on all of the following because so many others have done it perfectly already. To learn the specifics of any of the processes below, I suggest taking a workshop from someone in your area or visiting a well-established workshop center specializing in alternative processes. These include George Eastman House, Center for Alternative Photography, Penland School of Crafts, Maine Media Workshops, Santa Fe Workshops, Anderson Ranch, and a number of other great schools. Do some research and find a teacher/location that works best for you.

Cyanotype	Salt prints
Van Dyke brown	Collodion chloride
Albumen	Lumen
Gum bichromate	To name a few.

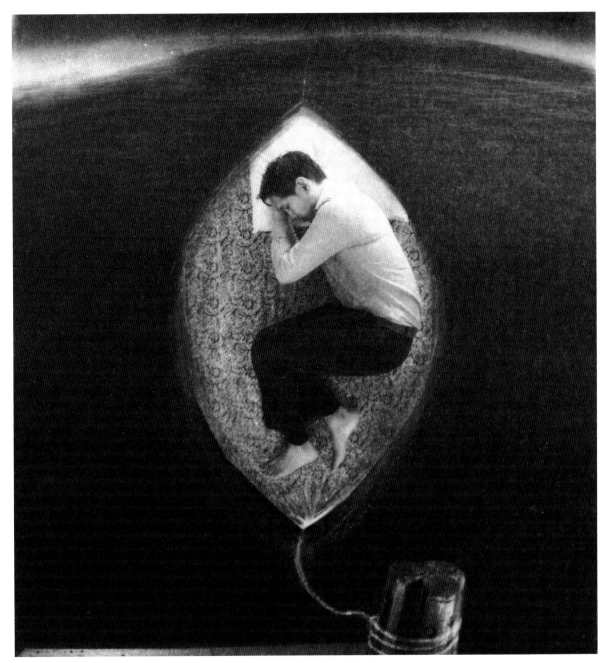

Figure 2.10 Jonah Calinawan, cyanotype titled *Sleep*

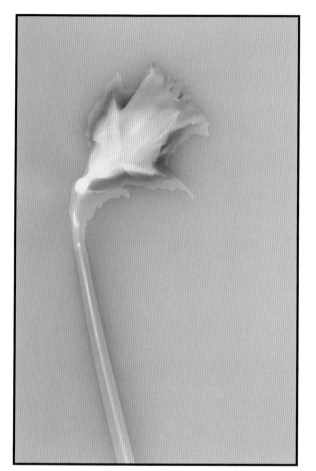 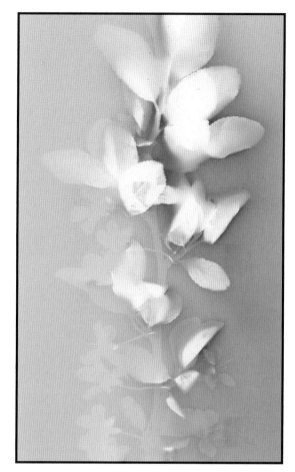

Figure 2.11 Generic lumen prints made with plant matter

WET PLATE COLLODION CONTACT POSITIVE

As listed previously, there are dozens of processes that can be used with inkjet transparencies, but the following is an important one to cover thoroughly due to the nature of accessibility and the expense of making large images. Traditionally, the size of your camera determined the size of the positive image you could make, be it an ambrotype or tintype, or more accurately described as positives on glass and metal respectively. Ambrotypes and tintypes are very specific

Figure 2.12 Brady Wilks, wet plate collodion contact positive.

historical processes that most collodion users rarely actually make. They are loosely used terms to describe positives that are on glass and metal. Either way, in order to have made a large image you had to have a camera capable of that size. If you haven't seen one in person, you can imagine that having a camera large enough to produce a 20 × 24in image would be substantially cumbersome and very impractical for field use.

There is a way around this expense with a process that I and I'm sure many others have figured out on their own, which I am referring to as *wet plate collodion contact positives*. You can take any digitized image—be it from a digital camera, film scan, or graphic design—and print an inkjet transparency positive enlargement at whatever size you desire for your final image. As long as you have the equipment to accommodate the plate size, you can make a positive as large as your equipment allows. Now, you only need the equipment associated with the chemistry and not the cumbersome, expensive, and sometimes rare ultra-large format cameras.

Nothing is quite like a large format or ultra-large format ambrotype made in-camera, but you can use an inkjet print positive on transparency film and make a contact print by directly placing the transparency positive onto the poured and sensitized plate. You can also marry the aesthetic qualities of wet plate collodion chemistry with images captured digitally by projecting an image, photographing a screen, or, in this case, using overhead transparency film.

Special care must be made when using this process. First, you must be familiar with wet plate collodion and you must also be familiar with making digital negatives and basic inkjet printing. Previous knowledge of inkjet printing to overhead projector (OHP) transparency film and wet plate collodion is required. There are no universal curve adjustments that work

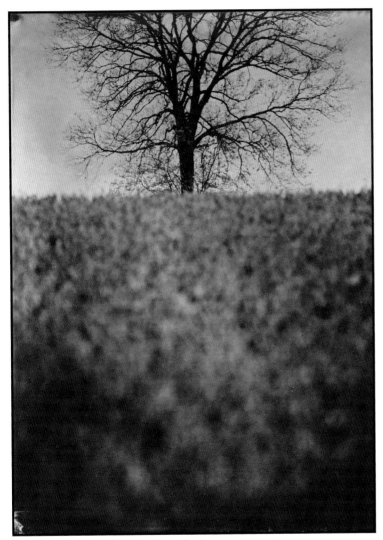

Figure 2.13 Brady Wilks, wet plate collodion contact positive

best for all images. You will make tests and alterations to your inkjet positive as you go, keeping in mind the density of your print and how that relates to the exposure of the silver on the surface of the plates.

PRELIMINARY THOUGHTS

As with any process that uses transparency film, you will want to make tests and perhaps adjust your image in Photoshop using something called *curves*. This is a feature that allows you to adjust your image to best match a specific process, in this case wet plate collodion positives. Unlike other processes, you must print greyscale positives, not negatives.

Step 1: Print Your Positive Transparency

Prepare your file and apply your curve adjustment or skip curves and use a combination of Photoshop levels along with shadows and highlights. I want to emphasize that there is no default filter of any kind. Every image is different so you must experiment a little with density, your images values, and exposure time. We are printing positives so you will need to keep in mind how collodion positives work. Your highlights are the areas where the silver is most dense created by the transparent part of your positive film. Anywhere the ink is present will of course block the light depending on its opacity. If the light is blocked then little to no silver is being exposed, in turn, leaving it the color of your substrate, black. Once you produce a positive that you would like to use, it might be a good idea to print multiples in case one gets damaged. I often print two positives for every printing session. Trying to reuse your negatives over and over will take a great deal of care in regards to cleaning and handling due to the silver nitrate and you risk the possibility of contaminating the next contact or staining materials permanently.

Step 2: Preparing Your Plate

As mentioned earlier, previous knowledge of wet plate collodion is required. Please display caution with the use of all chemicals associated with this process as they are flammable, explosive, carcinogenic, and poisonous to deadly effect. It is your responsibility to read safety sheets and precautions in order to handle the chemicals safely. Please study and use

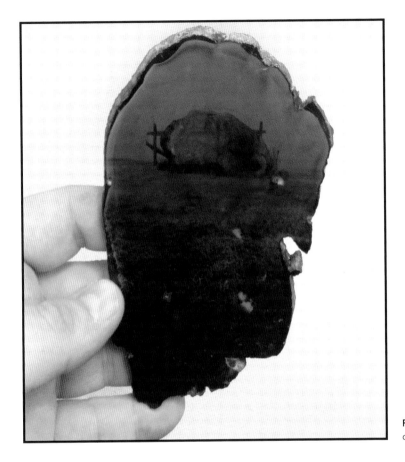

Figure 2.14 Brady Wilks, wet plate collodion contact positive on dark moss agate

all available guides provided with your chemistry or manual. If you would like to learn wet plate collodion, there are a lot of great instructors with various styles, strengths, and techniques. I suggest a workshop through Mark Osterman at George Eastman House, Jill Enfield at Maine Media Workshops, or a dozen other great instructors with various strengths and styles. Search around, ask around, and find who you like best.

Using trophy aluminum is standard practice with wet plate collodion positives, but you can also use other substrates such as obsidian, slate tiles, found objects, etc. Just be sure your object will fit in your silver bath, or you may need to tray

sensitize in the dark. With trophy aluminum I have found that you need to peel the protective coating off in a smooth fashion, otherwise you can leave behind stripe marks that show up in your plates later on. This usually isn't a problem if you peel it slowly and in one non-stop motion.

After your pour, put your plate in the sensitizing bath and prepare your developer and exposure station. Place something down that you don't mind getting stained, like a mat board, so that you do not stain your enlarger stand. After sensitizing the plate, you will need to quickly place your plate on this mat board, setting it under the enlarger or UV light source, but make sure your unit is off at this moment.

Step 3: Apply Transparency

Apply your transparency. DO NOT PLACE TRANSPARENCY INK SIDE DOWN. As some of you may know already, getting the ink media side of your transparency wet will damage it. Be sure to place the transparency ink side up and don't get any moisture (silver nitrate) on the ink side of the transparency. Also note that you are working with silver nitrate, which can stain. Be sure to use gloves when handling plates and when placing or lifting transparencies.

The surface of the collodion is very delicate and you must use special care when applying your transparency for two reasons. First, so that you do not damage the surface, and second, so that you do not leave any bubbles. Hold the transparency so that the center of the film is the lowest spot over the center of your plate. Lower the transparency onto the center of the plate and slowly let it work from the center out to the edges. Do not press down too much as you may slide the film and damage the delicate collodion layer. You can reposition, but do this too many times and you may find you are creating more flaws. You can also use a brayer or roller to rub out any bubbles or lift a corner to release bubbles trapped, but do this sparingly as you risk damaging your plate. If you roll it with too much

force, peeling the film off can bring with it the skin. Sliding the film will certainly damage the collodion layer. Just know that the silver nitrate, while wet, is acting like a seal, similar to using fluid when scanning negatives for those readers who are familiar with that process.

Step 4: Exposure

You may use an enlarger or a UV exposure unit. Using a medium format enlarger with a dichroic head, covering an 8 × 10 area of light might take 2–3 minutes to expose. A UV light source or exposure unit can work within seconds to expose. After you have tested and found the best exposure time for your device, you may proceed with a full image. Don't rush, use smaller tests to save chemistry and materials. Once you find an average time for your particular arrangement, it should remain consistent. For example, under an enlarger, if the distance of the light source remains the same, you can expect that if you used 3 minutes on the previous image, 3 minutes is a good place to start for the next one.

Step 5: Remove the Transparency

Take special care when removing the transparency: if your collodion peels, you need to rub it off, clean it, and polish the surface again. You may need to use subbing when using glass and polished stone. Lift it slowly from one end and place it on paper towels silver/wet side up, do not try to dry it at this point. Silver nitrate is present on the transparency film so take care not to stain things. You may also place it on a counter with the silver nitrate facing up but do not rub the film around as you might scratch your image. Set it in a safe place in the darkroom until it is time to clean it. After it is set aside, quickly take your plate over for development.

Step 6: Finish Processing

Finish the wet plate collodion positive process with development, wash, fix, wash, dry. Then optionally burnish and tint, finishing with varnish.

WARNING

.

Please be careful and read safety sheets on all chemicals.

It is your responsibility to read and handle the chemicals in accordance with the instructions provided by their respective parties. These instructions are to be used by those who already have experience using wet plate collodion chemistry.

Step 7: Clean the Transparency

Once you have used your transparency positive and finished a plate, you will want to remove the silver nitrate from the film's surface shortly after. Doing so under a safelight will ensure that the silver nitrate does not stain your image. Carefully wipe down the transparency with a series of 3 damp cotton balls, then a couple dry ones to buff off any remaining residue. If any silver nitrate is left behind it can stain your positive and you will have to reprint.

2.4 Alternative Enlargements

With a little thought, you can solve a number of problems or invent solutions to alternative image-making. The following are just a few processes making use of available materials and abstract thought for image solutions. Some of them can get downright silly, but if the end result is what the artist wants, then it is a success. There shouldn't be too much emphasis on how art is made anyhow, except for the sake of curiosity, teaching, learning, and the rare occasion when it is an important answer to a conceptual idea.

CELL PHONE ENLARGEMENTS

If you have a traditional darkroom or are looking to build one for wet processes; you can use a traditional enlarger to project an illuminated device such as a cell phone onto photo paper. Instead of using an enlarger light and a film negative, you can use an image that has been converted to black and white, and inverted to a negative displayed on your cell phone and slide it into the film carrier slot. The light of the cell phone then projects light from its screen through the enlarger lens onto the paper plane. With some focusing and exposure tests you can make enlargements from digitally projected images as long as your device is small and thin enough for the

enlarger. You can control exposure in various creative ways but the easiest is to stop down your enlarger lens and increase exposure times so that you can manually block or cap the lens without a precise timer control normally needed for fractions of seconds.

PROJECTOR ENLARGEMENTS

Similar to cell phone enlargements, you can use a converted image and connect it from a computer or video source to a projector. Focus the projector on a wall where you can pin up photographic paper or any light-sensitive process. The exposure can be controlled by a cap, and remember to try and keep exposure times long. The brightness of your projector, the distance to the paper, the image, and other variables will affect your exposure times. You can't stop down a projector lens so you will need to rely on computer controls to adjust the brightness. Everything should be fine if you are working in safe light conditions but be careful of your devices that might have other areas that emit light and could potentially fog paper. For example, if your projector has a control panel, it might be illuminated. You can block the area with something dense like mat board.

PHOTOGRAPHING ILLUMINATED DISPLAYS

Some artists who have large studio cameras using slow processes can make images of things that would otherwise be impossible. They can use a field camera to make exposures, bring it back into the studio and display it on a larger screen or computer screen. Then, they make an exposure of the screen. It is another way that, similar to wet plate collodion contact positive, the artist can make a large wet plate collodion positive of something like a hummingbird, frozen in flight.

COMPUTER DISPLAY CONTACT EXPOSURE

Another darkroom process that still requires a safe light room and chemistry to process the prints is performed through the use of a computer display or laptop screen. Before removing your light-sensitive paper, you will need to prepare your image and display it on your screen in reverse. You can use construction paper as a template so that you know where to place the paper when turning your screen on and off.

Open up your image in editing software that will allow you to convert it to black and white, then invert the image making it a negative. Place the image window somewhere on your screen that is not affected by any symbols when you turn your screen on and off. For example, a Mac computer displays an icon when you increase or decrease brightness. Place the image in an area of the screen that doesn't display this icon.

You should make tests by turning your screen on and off for short amounts of time. You might find the contrast to be flat among other potential flaws or faults. Just remember that if you want really sharp images, you probably won't want to try this method. It produces a soft image, embrace it should you choose.

3

CHAPTER 3

Substrate Acquisition and Considerations

In the case of art and alternative processes, substrate is the term that applies to any material that is used as a printing surface or foundation for receiving art. It is the media you use to print to, paint to, or use as a base. Paper, canvas, wood, metal, stone, tile, and many others are all examples of substrates.

If you can learn to be resourceful, you can save a lot of money on your materials and also stand out a little bit due to aesthetic differences. Each material has its own aesthetic and will alter or transform your art in different ways. First gather, then experiment, and finish with an intentional choice. Don't choose something simply to be different. Choose a process or working method because your art couldn't look any other way.

3.1 Aged Books and Paper

Aged and antique books can provide a good source for papers. Many old books have several blank sheets of paper in the front and back sections. Additionally, they may have colophons, images, or symbols that can be used creatively or incorporated into your art. Try even using the pages with written text, messages to loved ones, or the price history, usually written in pencil.

All pages within books vary based on their age, the manufacturer, and how many pages are available. It's a bonus

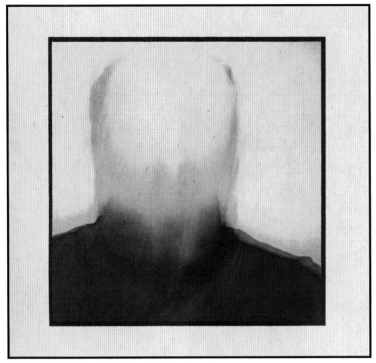

Figure 3.1 Brady Wilks, Untitled self portrait inkjet print on found antique paper.

to find books that would otherwise be going to the trash. Salvaging some of the blank or mostly blank paper can work well to build up a collection of papers and sizes. Don't worry about 20 pages that are all matched for a specific show. Part of the beauty of this process or method is the variation. If you are focused on finding books with lots of blank pages you might search for and find antique journals that are blank. Another source for antique paper are photo albums that were designed to have adhesives used to attach photos as opposed to windows or sleeves.

Finding the books can be a challenge but check antique stores, thrift stores, used book stores, antique book stores, junk shops, the trash, a neighbor, yard sales, flea markets, etc. Be sure to keep the price in mind when buying books. A $10 book for two useable pages is not as good as a $1 book for

Figure 3.2 Kitty Hubbard, *2 Bags of Groceries* – pigment ink, pen, stamps and colored pencils on repurposed paper grocery bags

four pages. Sometimes you have to pass up the books in the antique store because of their expense and value of being undamaged. They are usually worth something more than the weight of paper. If it is a special topic or has illustrations, it might be a bad idea to damage it or even pay the hefty price for a single sheet of paper, unless of course there is a stain you must have.

Some artists have chosen to use book covers with their end pages as a substrate to make art. Others choose books that are severely damaged or stained as an aesthetic choice. An artist may decide on using paper that has yellowed over time or has a message inside the cover that is integrated into the work. Perhaps a reclaimed paper bag?

Whatever your choices are, there are some considerations to be made. For example, most aged paper is not archival, meaning there were acids in the paper that caused it to yellow and break down over time. It is OK to use these materials but do so knowing what you are getting into and how your work will continue to change over time. Use materials that will preserve your substrate, such as acrylic, clear coat sprays, and resins.

3.2 Reclaimed and Scrap Wood

There are several processes that allow for the use of substrates other than papers. Wood is a great substrate for various processes such as transfers, installations, mixed media, and other mediums. Reclaimed wood is usually obtained from a previously unusable state such as a fallen barn, various structures, rail cars, whiskey barrels, and even sunken trees. The point is that you may be able to reclaim wood on your own for free. When structures fall down, some landowners allow

people to come and salvage its materials, as it may save them on the cost of removal or dump fees.

Additionally, there is scrap wood or wood that is otherwise destined for the landfill. Pallets, crates, demolition jobs, wood shop remnants, framer scraps, and a number of other sources will provide you with tons of material.

Similar to paper, you will want to consider pre-treating the wood or preparing it in a way that best suits your chosen medium and other materials. You will want to consider the following characteristics and actions when making decisions.

Cutting the wood to size allows you to plan or preconceive a visual idea, allowing you to make work for the given size, or at least print for the given size. Wood color and texture will vary and those characteristics should be considered as well. Some artists may choose to plane to a certain thickness before using as a substrate. They might also choose to sand or rough up the surface before transfer.

Equally important is the consideration regarding object permanence and how your given process will integrate. For example, an acrylic gel lift and transfer on wood requires several coats of gel on the wood before transfer. The wood has acid in it that could affect the color of the original print more than the aesthetic of the transfer. Using several coats of gel acts as a barrier. Wood also expands and contracts with humidity. Over time, this could affect your image if humidity conditions are constantly changing. Some woods are denser than others and are therefore more forgiving. The thickness of the wood could also affect the amount of movement, along with whether or not the wood is quarter-sawn. It is much easier to do research on types of wood to use when you can buy it from a supplier, but if you are reclaiming wood, it might be difficult to identify the species if it has been painted or is faded. Softwoods like pine, and even softer hardwoods like poplar, are common in

construction and these tend to warp easily. Always do a few tests of your materials before committing to a whole series.

3.3 Found Objects

A found object is something that is found or reclaimed to be used as art. More traditionally, an artist working with found objects is doing a bit of construction or assemblage. Keys, gears, computer parts, mechanical objects, old toys, and other things are used by artists making found object sculptures or incorporating objects into paintings, shadow boxes, installations, or other mediums. In the context of substrates, you will want to look for found objects that can be used as such. These would tend to be larger, or at least large enough to support an image.

Some examples of found object substrates include sheet metal and old discarded corkboard. These can offer a great base for transferring images or for use as a painting substrate where you will use photographs or graphics as collage along with paint in a more traditional mixed-media approach.

Clocks, mirrors, glass, old art, door panels, doors, computer monitors, and screens are just a few examples of surfaces that can be used as image substrates. An artist may choose to use functioning computer displays and transfer images on top, allowing imagery to play behind, illuminating the photograph.

Old tiles, bricks, and stones are other examples of found objects that can be used creatively to support your imagery. Experiment first, then decide on what material is best for your art.

Figures 3.3–3.6 show examples of artists using found objects as substrates.

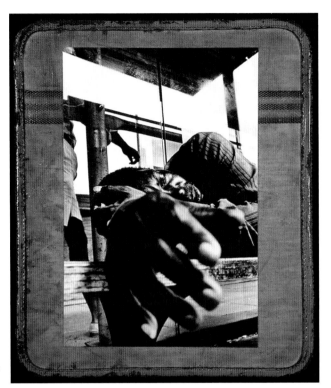

Figure 3.3 & 3.4 Joseph Mills, *Untitled* – varnished silver prints on found objects

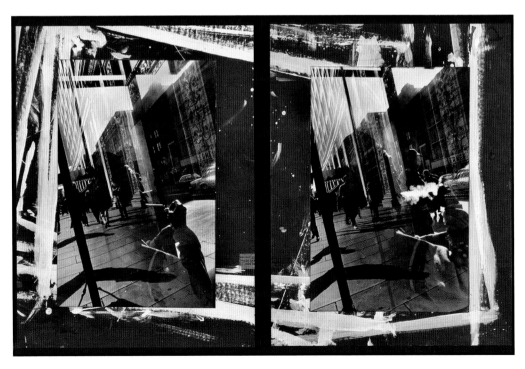

Figure 3.5 Beverly Rayner, *Emotional Baggage* – an integration of object and imagery

Figure 3.6 Beverly Rayner, *Convolutions of Time and Memory* – an integration of object and imagery

3.4 Sheet Metal

Sheet metal was mentioned previously as being a found object or material, but that doesn't exclude the possibility of buying your own. There are a number of materials you can buy, including things such as copper and aluminum for use in printing and transferring. In this regard, you don't have to rely on finding the right surface, you can experiment and decide on your own which material is best to use.

As a side note, there are a number of companies that will print to metal as well as a number of materials you can use to coat sheet metal so that you can feed it through your large format color printer. This is becoming pretty popular so we will focus on the alternatives and the decisions to make when selecting various materials.

There are a lot of considerations you must take into account when selecting and buying metal. The material, thickness, surface, finish, and patina are only a few of the variables to be considered. Metal is heavy, so the larger and thicker the material, the more limited you are in presentation and the higher the expense. The thickness also directly affects your ability to use it as an inkjet print medium. Professional printer brands can accommodate varied thicknesses but you will need to confirm with your printer manufacturer what mediums and sizes they will accept. Damaging a print head is not cheap.

Using sheet metal for art other than inkjet prints usually comes down to mixed media, image transfer, and other more sculptural or dimensional processes. Another important thing you must consider with any process is cleaning the metal. Depending on your source, the metal might come really dirty, partly dirty, or almost clean. It is advisable to clean the surface well before using it. Also use caution: cut metal obtained from

a supplier can still be sharp and any metal shavings or burrs left behind can be a hazard. Metal dust in the eye or a metal splinter/cut on the hand is not fun.

The use of a citrus cleaner or other solvent will assist in removing any grease; the cleaner can then be removed with soap and water. The final step would be to use a solvent that will evaporate, such as isopropyl alcohol. Take care when cleaning your surfaces as they can scratch. Some artists simply use rags, others use a combination of steel wool followed with a degreaser, then clean the surface with sponge and soap followed by a polishing cloth and alcohol. You will discover the cleaning process that is best for you.

If you plan to use metal for inkjet prints and you don't purchase pre-coated material, you will need to apply your own pre-coat material such as inkAID™. A few coats of inkAID™ applied one at a time with a foam brush should work well if you brush it on evenly. Once the coating is dry you will want to use a double stick tape to tape it down to a carrier sheet. A carrier sheet is a piece of paper larger than your metal so that your printer can grip and feed the media through as well as allow for artist options such as over-printing the edge or edge-to-edge printing.

If you plan to use the metal as a transfer substrate, you may want to mount it to something that is more rigid. If you apply too much pressure to the plate during braying or burnishing, you might bend or bow the metal.

In the next chapter we will provide examples of ways to manipulate the substrate for various effects, including fuming, oxidizing, and other finishes.

3.5 Stone and Tile

Tiles are another great substrate for processes such as image transfer. If you like to work in a small or medium format, you will have endless options of tile materials, textures, and colors. Ceramic tiles are cheap and readily available. You may also consider using stone tiles such as slate or granite.

As with all the other substrate materials, you need to consider the final product or art piece. If you transfer an image to a substrate material like granite or sandstone, not only will the texture be altered but also, if you remove enough paper, the color of the substrate will come through the imagery. In some cases it means that your substrate color will be your brightest highlight. There will be more discussion of highlight retention in the transfer section.

One advantage that artists have when using titles comes in the form of mosaic. You can split a large print into smaller pieces and then transfer them to tiles for arrangement. If your printer can only print to a certain size, then you can grid your original image and print sections to transfer to and reassemble the image as tiles.

NOTES

• •

4

CHAPTER 4

Substrate Manipulation

Beyond using alternatives in substrates, you can alter and manipulate them as well. The following is a list of substrates and various manipulations. Just to be clear, not all substrates or manipulations can be used with all processes. In fact, there are very few examples available. Use this section as a place to start. Search for examples in their respective topics and develop your own working methods.

4.1 Metal

Artists working with metal rely on a number of manipulations for things like welded furniture, sculptures, armatures, and assemblages. Physically distressing, marking the metal, giving it a patina, and sealing the work are some of the steps in a basic workflow for some artists. Here are a few more details regarding the manipulation of metal substrates.

DISTRESSING

There are many options for distressing your metal surfaces. Think about how you would like to use your substrate and what process you are using. Some distressing techniques or other alterations might not show through the process in the final product. For example, if you are using the metal as a substrate for acrylic gel lifts and your acrylic skins are really thick, then the texture of the substrate might not come through. However, any darkening or lightening from

tarnishing or created patinas with various chemical reactions would show through the transparent areas. If you are using aluminum as an inkjet printing substrate you can distress the surface or create a texture before coating it with a product like inkAID™. The texture could affect how the ink is applied to the aluminum and the course surface could potentially damage print heads, so use caution. Another use for aluminum is for artists using wet plate collodion. Aluminum sheets are used as the image substrate for wet plate collodion positives. Distressing the surface could potentially change various steps. Pouring the collodion will certainly be affected as some areas will be thicker than others and it may set up unevenly on the surface and pour off differently. The same is true with sensitizing, exposure, and possibly development. The chemicals will not flow smoothly if a texture is altering the path or holding excess chemistry. If there is debris on the surface, it could affect your various baths or stick to the surface, giving it bumps and ultimately a change in the materials and final product.

PATINAS

With the use of common household chemicals or even industrial strength chemicals, you can create a number of different looks for various metal surfaces. There are entire books written about creating various patinas and surfaces, but here are a few ideas for getting you started and at least thinking about the possibilities.

Copper

This material is not a common substrate due to its expense. However, should you choose to work with copper you will find that it is easy to create a number of manipulations on included patinas. There are several ways to oxidize your metal. Some are made using household chemicals such as ammonia and vinegar. You may also try commercial products that are specifically designed to create colored patinas. There are

hundreds of resources for working with metal and patina formulas for various metals.

Aluminum

This material is actually more difficult to create a patina on than other metals like copper and bronze. However, there are some things you can do to create a patina on aluminum if so desired. There are some commercial products that can add a real patina to your aluminum. There are other options like painting and sealing, but there is a risk of these chipping off. There is another option of anodizing aluminum, but that can be quite costly and not something practical for aluminum sheeting.

No matter what metal you choose, it will mostly likely be in a thin sheet form for the sake of weight and cost.

Sealing Your Patina

If you do not seal your metal, it may continue to tarnish and oxidize. To suspend the tarnishing and oxidation of metal, you will need to clean it and use a sealer such as a clear lacquer or wax. Please note that the surface you create might not work well with various processes. Wax works great as a base for encaustics but not for solvent transfers.

METAL LEAFING

Although leafing isn't a substrate on its own, you can apply gold or silver leafing to a number of surfaces including metal, wood, and glass, among others. This gives the substrate variations in metal surfaces or appearance. For example, applying gold leaf on one side of a piece of glass, then transferring an image to the other side will allow the leafing to show through the transparent areas and will also give it a sense of depth and dimension due to its distance from the transfer on the other side of the glass.

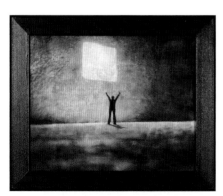

Figure 4.1 Blue Mitchell, *Illumination* from *Chasing the Afterglow* series – acrylic lift on silver leaf, resin, hand-painted frame

Another example of transforming an image into a more dimensional piece of work comes from Blue Mitchell's

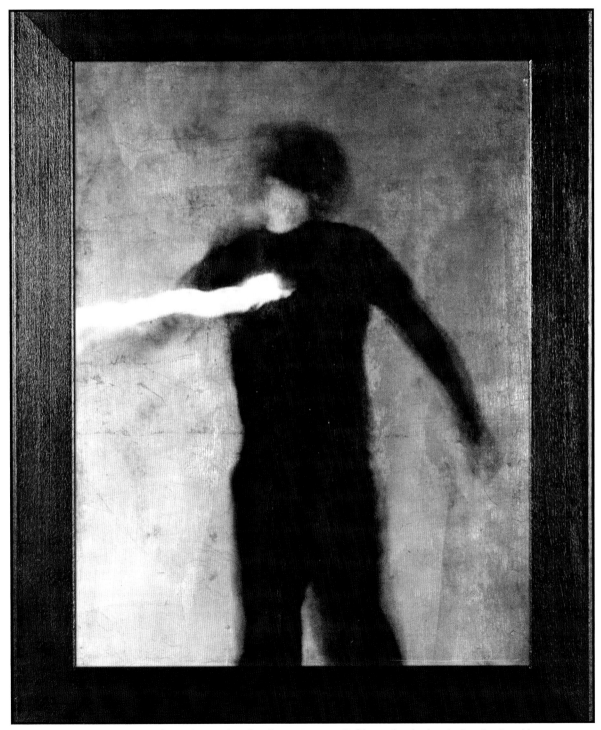

Figure 4.2 Blue Mitchell, *Fusion* from *Chasing the Afterglow* series – acrylic lift on silver leaf, resin, hand-painted frame

methods of combining the use of silver leafing and acrylic gel lifts to enhance the luminance of the image as well as providing a more tactile texture. In Chapter 5 we cover various lift techniques and Blue Mitchell provides a perfect example of what is possible through specific combinations of image-making.

REPOUSSÉ AND CHASING

Repoussé and Chasing are two sides of a process that consists of hammering and pressing a relief into the back side and front side (respectively) of a thin sheet of metal. In part or in combination, the artist can create a depressed or raised texture before or after applying an image to a substrate. This opens up a lot of possibilities for image-making and adding texture, 3D elements, depth, and dimension.

For example, you could apply an acrylic gel lift skin to the thin metal surface and wait for it to dry. Once dry, making depressions from the back side will alter the texture of the front, image side. The nature of acrylic gel is somewhat elastic; so long as the relief isn't too deep, you can add texture to the image from the backside after transferring. If you create your relief before transfer it would be difficult to use a brayer to properly seal the image with enough pressure. This pressure could damage your relief or flatten it out. Practice with small images and small pieces of metal before using this technique on your final product.

4.2 Wood

Distressing the surface of wood is similar to metal. You can use a wide variety of tools or materials to alter the surface and appearance of the wood. Carving chisels, knives, grinders, sanders, electronic etchers, torches, and a dozen other tools can

be used to physically change the texture or relief structure of the wood, emphasizing wood grain or other abstract patterns.

FUMING AND OXIDIZING

Some chemicals can alter the wood's color through a process called fuming. Ammonia fuming is very dangerous and requires caution and safety gear including goggles and a respirator. The materials are put in a chamber or container and the fumes from concentrated ammonia mix with the tannins in the wood, causing a color-changing chemical reaction. There are a number of variables that change the color. These include the wood species, chamber size, concentration of the ammonia, amount of ammonia, temperature, and air-tightness of the chamber. For small pieces, you could use a bucket and a plastic bag that has been taped shut. For larger pieces or higher production, you can use a larger plastic container such as a plastic storage bin or storage closet, as long as you can make it airtight. Please refer to a professional source and follow all safety guidelines before trying fuming on your own.

Another variation of oxidizing begins with placing a few pieces of steel wool in vinegar and allowing the mixture to sit covered for a few days. Then brew a pot of black tea using several teabags. Begin by applying the tea to the surface of the wood with a brush and allow it to dry. Next, apply the vinegar solution. After a few minutes, your wood will begin to change in color.

BURNING

With a torch or other flame source, you can burn or char your substrate for various effects or appearances. Spots, rings, stripes, edge charring, or a number of other effects can be created on the substrate before beginning any image-making process. A popular technique for distressing wood is to use a torch to lightly and evenly char the surface or edges. After you have darkened or charred the wood, you can use fine

grit sandpaper and sand down the high spots in the relief. This can reveal and accentuate the wood grain pattern. Always work outdoors in a fire-safe area, take caution, and follow the instructions of your flame and fuel source.

STAINING AND PAINTING

Unlike fuming, which also changes the color of the wood, you can use a stain or washes of paint to change the tonality of your substrate. For example, if you were using a vibrant colored wood such as yellow heart and you wished to tone down the intensity of the yellow, you could use a series of thin washes of watered down acrylic paint. Similarly, you could choose a stain to darken the wood.

4.3 Glass and Mirrors

FOGGING

Some users of antique large-format cameras find that they need to make their own ground glass. Ground glass is a piece of frosted glass that shows the projection of a lens, allowing the user to focus their composition. In order to make this frosted glass, some use grinding grit paste and another piece of glass to rub in the paste and score the surface. Working first with a course grit such as 200 and a little bit of water, lay another piece of glass on top and rub it around, checking on your progress. Then, graduate to 400 and eventually 600 grit paste. This should provide the quickest and most even treatment. If you begin this process with a fine grit such as 600, skipping the courser pastes, the process will take a long time. Skipping from 200 to 600 grit paste may result in an uneven treatment. You might also find that you are getting areas that are more affected than other areas. This might be due to the flatness of your glass or uneven pressure. Most new glass shouldn't have a problem with this.

Take caution if you are cutting your own glass. Be sure to use a sharpening stone along the edges of both sides of the glass to remove the sharp edge as it is dangerous otherwise.

There are many other methods for frosting glass such as acid etching, pastes, creams, and sand blasting. The primary approach for those products is to make a stencil pattern or design and apply it to the glass as a way to block some areas but let the etching paste or sand blasting media affect the exposed areas. Just keep in mind what your intention is with the various manipulations to your substrate and how it might transform your image.

LEAFING AND COLLAGE

Leafing was touched on in the metal section but can also be applied to glass. As previously described, leafing or collaging one side of a piece of glass can add depth because of the distance between the two sides of the glass. If your image is something like a transfer there should be some transparent areas allowing the substrate to show through, in this case, gold leafing or collage material behind the glass.

4.4 Paper

DISTRESSING

There are many ways to distress your paper substrate. Some of these options include: getting the paper damp in some areas and then letting it dry in order to ripple the surface, slightly crumpling your paper, sanding the edges of your paper or using a sharp object to scrape the edges, using a ripping bar or ruler as a straight edge for ripping off the edges of your paper creating more fibers or even a decaled edge look. The options for distressing paper are endless. You can even be as drastic as

setting your paper down on the asphalt and walking all over it or using fire to char or burn the paper.

STAINING

Staining can be done to the entire sheet of paper, or you can make it look more aged or abused by creating wine stains, coffee rings, water spots, and other types of liquid-based alterations. Practice first with some experimentation. Try experimenting by soaking a whole sheet of paper in a bath of tea or coffee. Try splattering a red wine. Try dipping the paper's edges in the stain. Intentionally spill a little coffee over the edge of your mug and set it to rest on your paper. There are ways to dry and preserve these changes depending on your chosen process.

BURNING

There really isn't much need for instructions on burning paper but there are many considerations to be made. First, of course, is safety. Work outdoors or in a well-ventilated area as with any other process that deals with fumes, vapors, or heating. Second is the concern of burning the paper too much before use in a printer or other process. If the paper is too fragile after burning, you can not only damage the paper by putting it through a printer, but you can also damage the printer by getting it clogged or jammed up with broken paper bits, affecting the printer heads or causing ink smearing and streaking.

BOOKS

Old books can find new life by upcycling them into your own art. In relation to photography and mixed media, it would be easy to transfer images in a number of ways to each page turning the book into a collection of your own work. They can also be used as a sculptural base, carving and cutting pages and incorporating imagery into the 3D piece of art.

Figure 4.3 Dan Estabrook, *The Boy* – this work was further manipulated by creating various distressed conditions, including staining, after the image was made but the same can be done beforehand; it depends on your intended outcome

4.5 Fabrics, Ceramics, and Other Materials

Figure 4.4 Tamara Hubbard, *Untitled* – cyanotype on silk

There are so many other materials that could be covered. Fabric, ceramic, tile, slate, plastic, and stone can all be manipulated in various ways, sharing some of the same approaches as other materials. It really is dependent on two factors. First, the limit of your creativity and, second, the consideration of permanence and how long these works of art will last. It's important to remember that materials can change over time due to the elements and other factors. How important is it for the material to last a long time?

NOTES

. .

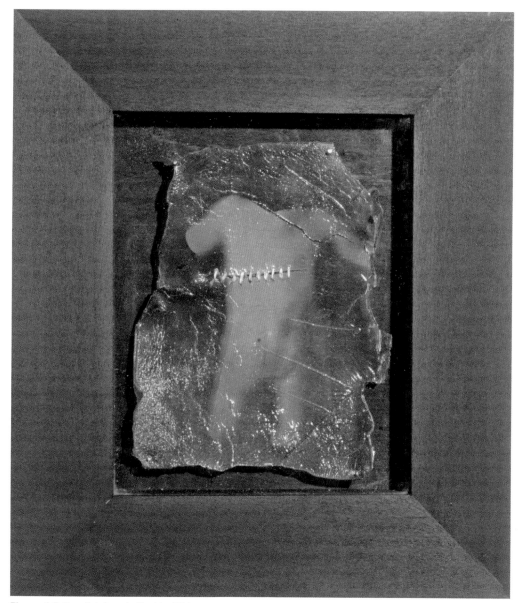

Figure 4.5 Dan Estabrook, *Untitled* Skin

5

CHAPTER 5
Transfers and Lifts

Figure 5.1 Brady Wilks, *Potomac Resident* – acrylic gel lift/transfer on wood

5.1 Acrylic Gel Lifts/Transfers

The acrylic gel lift/transfer is a process with many stages, ultimately enabling the artist to apply their photographic or printed image work to a wide variety of surfaces. The process entails the creation of a positive print, applying acrylic gel to the print, curing the gel, soaking the gel coated print, removing the paper backing, and then applying the final suspended ink to a new surface. This exercise will illustrate the non-traditional acrylic side down version of the process that has been developed as a way to further control and manipulate the photograph. It celebrates the old transfer aesthetic of being a reverse of the original capture and allows more manipulation of the ink side before it is sealed. Although it may require more work, patience, and care than other transfer processes, it is a wonderful variation and has its own unique aesthetic quality.

SURFACE SUBSTRATE OPTIONS

Paper
Although it may seem redundant to transfer from paper to paper, with the wide variety of handmade and fine art papers available, this process can in fact produce great results. As can be seen through the process, the acrylic skin can be folded, stretched, and creased while being applied to the substrate of choice. These textures and anomalies of ink loss, creases, and bubbles can still be taken advantage of even if paper is the desired final substrate. This is a similar look to Polaroid emulsion lifts.

Canvas
Because many printers cannot accept very thick canvas rolls, this technique can be utilized to apply images to canvas. Many painters and mixed media artists utilize similar techniques in their work.

SUPPLIES

- Inkjet printer
- Standard 20lb matte inkjet printer paper/typing paper
- Acrylic gel medium (choice of transparent matte or gloss)
- Synthetic or natural fiber bristle brush around 1in
- Palette knife (optional)
- Acrylic or rubber brayer (rubber works best with textured substrates)
- Hairdryer (one with multiple settings for air speed with hot/cold setting)
- Shallow tray or plate to soak prints
- Substrate material (desired final surface for print)
- Scissors
- Razor knife (optional)

NOTE
· · · · · · · · · · · · · · · · · ·

Suggested species list: oak, red oak, poplar, mulberry, Bradford pear, apple, lilac, maple (all varieties), spalted maple, box elder, ash, yellow heart, lati, and birch.

Wood

Light colored woods will produce the highest contrast print, as the wood color and structure will show through the translucent areas. However, when using wood, it is best to use a higher contrast image to compensate. Darker woods tend to be more difficult to work with due to the lack of contrast you will have in the final image. The wood can be oriented in a way such that the striations of the grain support and enhance the image. This is a personal preference choice.

Glass

Using glass allows for the option of back illumination. Also, additional substrate materials such as gold leafing and glass beading can be applied to the back of the glass and seen without altering the texture of the transfer itself. This can enhance the depth and dimension of the image.

Mirror

Mounting to mirrors is similar to working with glass; however, the reflection on the underside of the skin provides additional depth and background textures that move with the viewer.

Sandstone

Sandstone, slate, and other stone tiles have a wonderful texture that, when paired with the transfer, add a unique surface that is difficult to reproduce otherwise. There are also many gel mediums containing various texture materials such as sand, glass beads, and fibers to create varied textures on a number of surfaces.

Marble

Similar to wood, the striations within various rock formations can provide interesting patterns to be revealed underneath the transfer skin. The difference is that marble usually comes polished while most wood grain allows a relief to show through.

Found Objects, Books, and Fabric

Essentially, just about any material can be used as a substrate: lampshades, barn siding, cigar boxes, instruments, books, plastic, and any other found object able to accept the application of the thin skin. Each substrate will, of course, carry its own requirements for a successful transfer.

ACRYLIC SIDE DOWN OR PAPER VEILED METHOD

The method developed for this instruction uses gel on paper to suspend the ink. The paper is removed via water and the transfer is placed with the image in reverse, acrylic side down/paper up. This is the process used to further manipulate and control the transfer through paper removal in stages, checking the paper veil in dried stages.

Step 1: Make a Print

Using white typing paper, print the desired image using a plain paper profile with at least 720ppi photo quality resolution. The image should be fairly high contrast. It is important to note that regardless of the substrate being transferred onto, some details will be lost, especially in areas of shadow. This is simply a part of the process. The darker the substrate, the lower the contrast will be in the end due to the material showing through the highlights.

Step 2: Coat and Cure the Print

Note: There are many variations on coating the print. This stage is extremely important. In order to make the most of your transfer, it is important that this step is approached with patience, regardless of the coating method being employed.

1. The first method is to apply a thin coat of gel by using a brush to apply it in a single direction across the entire image. After applying this thin coat, it is advisable to use

Figure 5.2 This transfer was made by removing most of the paper to reveal all of the wood and printed image. Only small bits of paper remain on the surface. This is much different than the second approach, which retains more paper underneath as a highlight.

a hairdryer on a cool or medium heat setting to accelerate drying and curing time. Do not use a high heat setting as it could damage the gel. However, this hot setting can be used to burn in, boil, and bubble the gel skin if that particular aesthetic is desired in the piece. Repeat this layering at least 4 to 8 times, alternating brush stroke direction between layers.

2. The second method is to apply a few thick coats of gel, curing and drying between each coat. These thicker coats take a lot longer to dry and it is important to only use the cool setting on the hairdryer. Hot air could potentially damage and alter the gel with bubbles, cracks, and imperfect thicknesses. This may be the desired effect; however, it is not as predictable as with thinner layers of gel.

3. The third method is to apply a single very thick coat using a palette knife to glop the gel down off to one side and distribute the gel across the image in 2–3 soft-handed strokes. The gel will even out slightly, but this method could be used to get some heavy textures on the surface similar to encaustic/wax work. Typically, it will require 8–10 hours minimum for thicker applications to dry. When using this method, several images can be prepared for transfer and coated at once, letting them dry and cure overnight to full transparency. (Drying times will vary across regions due to humidity and temperature.)

Many other variations can be discovered through experimentation. A successful starting point would be 8 thin layers, alternating brush stroke direction and fully curing between each coat.

Alterations: A small amount of pigment can be added to the gel medium but should be done sparingly in order to maintain transparency. Another alteration could be made by brushing in some texture and tracing elements of the image to produce depth and dimension. Using textured gel at this stage makes paper removal difficult, but some textured gels work very well as a final coat.

Before moving to the soaking stage, the image may be trimmed if desired so that it becomes borderless, without paper edges.

Step 3: Soak the Print

Depending on the print size, a tray or container will be needed that can accommodate the full size of the image or more. When working small, a simple plate can be used with very little water. Larger images will require a larger tray.

Distilled water or most well water works best. A warm to mildly hot water temperature is best when removing the paper

SPECIAL NOTE

When using a hairdryer, do not cure the gel with the paper lying flat on a stiff surface for too long as it could create moisture pockets or "sweat" on the underside of the paper. Instead, hold up one corner or side of the paper carefully while drying the print with a hairdryer. If this is not done, it could result in bubbling or a breakdown of the gel when soaked in water. Curing fully is the most important consideration before soaking.

backing, as the fibers of the paper will soften more easily. Using water that is too hot could damage the gel or cause it to bubble. This could be used creatively, but the bubbles will remove most of the ink in those areas. Lukewarm water produces the best results. This ranges between 98° and 105° Fahrenheit.

Soak the print, gel side down. The water can be seen penetrating the paper backing. Before submerging the paper, fine-grain sandpaper can be used on the back to accelerate the water penetration, but is not necessary with typing paper. If typing paper is used, the soaking time is very quick. If fine art paper is used, such as Somerset velvet or enhanced mat, soaking times will be much longer. Typing paper soaking times range from 1 to 5 minutes but some paper require hours of soaking. This process cannot be rushed.

Step 4: Release the Paper Backing

Once the print has soaked, leave it in the water and start to gently rub the paper side in an easy motion side-to-side starting in the center. You may consider changing the water to make it warm again. (Using cold water makes the gel act brittle and it can be easily torn.) The fibers of the paper will begin to pill and roll away gently. Once the first layer of the paper is removed in the center, start to work from the center out to the edges, holding the print down with one hand and gently rubbing with the other. This step is extremely delicate! Be careful not to rub too hard or too much or all of the ink can be lost.

The other methods don't require the removal of all the paper. This process is a little more involved as the paper must be removed in several layers, rinsing the print and adding fresh water so the pulp doesn't build up. If too much pulp is allowed to build up in the tray, it can slip under the gel layer. If this occurs, the pulp can easily remove ink from the surface of the image by incidental agitation. Again, this could be used in an intentional way for further distortions and loss of details.

Once the desired amount of paper has been removed, carefully rinse the gel image, removing undesired pills and fibers from the surface.

Step 5: Dry the Skin

Drape the gel skin over a drying rack or another smooth, non-stick surface. Be careful not to allow the skin to become stuck to a surface or other paper materials as this could damage or alter the skin. Alternately, the gel skin may be dried with a hairdryer on a cool setting to accelerate the process. It may be draped across the hand or arm while drying, if small enough. The end result is not a thoroughly dried film, rather the acrylic side of the image should be mostly dry and the ink side should still be damp but not dripping.

It is essential to work quickly so that the ink side isn't completely dry. Coat the substrate surface with an even amount of gel medium. This layer should not be too thick or too thin. It is difficult to describe the correct gel thickness, it is best to learn through practice. Do not allow this layer to dry as it acts as glue between the substrate and the gel transfer.

Step 7: Apply the Gel Skin

The transfer will be applied with the paper/ink side up and the acrylic layers face down. Lay the gel skin gently on the surface. At this stage, purposeful stretching, folding, creasing, ripping, etc. may be done. Depending on the original coating method, the skin might be very delicate and brittle.

Use the brayer to roll out the air bubbles starting in the center and working up, then starting in the center and working down. Do this until all the air bubbles are out, unless those effects are preferred. If you are using a thick substrate such as wood or glass and the gel skin has been applied over the surface and rolled out, fold the excess skin over the edge of the substrate and spread some of the excess gel around the edges to act as glue.

SPECIAL NOTE

Do not dry the ink side. Be sure only to dry the back side; the transfer must be finished while the ink side is still wet. This will allow the removal of any last bits of paper. While it is still wet, it will be difficult to tell if all of the paper has been removed. If any paper is left, it will eventually dry white. Again, this effect might be desired for a certain aesthetic quality.

SPECIAL NOTE
· · · · · · · · · · · · · · · · · ·

If a high heat setting is used, air pockets and bubbles may be produced due to expansion. This is an interesting effect but not always desired. To avoid them, use a very low heat or cool setting on your hairdryer. You can also control drying and temperature by the distance that you hold the dryer.

At this stage, if desired, more of the remaining paper backing can be removed from the surface carefully with a wet finger, but be extremely cautious to not use too much pressure or you will remove all the ink as well. Once you have removed all the paper you desire, let it dry and double check that the right amount of paper has been removed.

Remember that with this method, the paper is on top of the inkjet print. This means that if there is too much paper left behind, it will dry white and obscure the inkjet print. If you like the way it looks after it has dried then you may use more gel as topcoats to lock in and project the print. As before, brush on at least two additional layers in different directions and cure between coats to finish the process.

If there are any creases, folds, tears, or bubbles, excess gel will build up in those areas as you brush. Three things can be done to remedy this issue. First, the thin areas can be cured with a hairdryer and then the excess in the areas can be rubbed out. Second, the brush can be cleaned and used to wipe up the excess in those areas. If using the brush method, be sure that the direction of the strokes is not changed or it will be evident once the gel is cured. As a third option, a single thick coat can be applied and allowed to dry overnight. However, with this option there are risks of dust, hair, or insects getting stuck on the surface before totally cured.

Step 8: Finishing
The finishing of your work is full of options and discussed broadly in Chapter 10. The most important thing is to apply finishing coats of acrylic gel medium in a manner similar to the original print before transfer, alternating direction and curing in between layers as described above. Trimming and folding edges provides a clean presentation. Painting the sides or framing the work would provide a gallery-ready presentation. Beeswax or synthetic wax (encaustic) can be used to encase the print and offer added levels of dimension to the lift.

ACRYLIC SIDE UP OR RETAINED HIGHLIGHT METHOD

The method developed for this tutorial uses gel on paper to suspend the ink. The paper is removed via water and the transfer is placed with the ink side down on the blank surface, producing no inversion or reversal. The benefit here is more control and selective paper removal to retain highlights.

Step 1: Make a Print

Using plain white copy paper with a paper weight of 20lb, print the desired image using a plain paper profile with at least 720ppi photo quality resolution. The image should be fairly high contrast. It is important to note that regardless of the substrate being transferred onto, some details will be lost, especially in areas of shadow. This is simply part of the process. The darker the substrate, the lower the contrast will be in the end due to the material showing through the highlights.

Be sure to print an image leaving some room for a border. This border is used to brush gel on and past the image area, ensuring proper gel distribution. The edges can be trimmed later for a clean straight transfer. If you leave the edges untrimmed, they will easily tear but could provide interesting edges for images centered on substrates as opposed to wrapping over them completely.

Additionally, watch for the usual printer issues such as banding. These flaws will show up in your final transfer so be sure to refer to your printer's manual for regular maintenance.

Step 2: Coat and Cure the Print

There are many variations on coating the print. This stage is extremely important. In order to make the most of your transfer, it is important that this step is approached with patience, regardless of the coating method being employed.

Figure 5.3 Brady Wilks, *Giants and the Dynamic* – acrylic gel lift/transfer on wood

1. My preferred method is to apply several thin coats in alternating directions (6 to 12 layers) drying between each, alternating direction. Start by applying a thin coat of gel with a brush in a single direction across the entire image horizontally. After applying this thin coat, use a hairdryer on a cool or medium heat setting to accelerate drying and curing time. Apply another thin coat vertically, altering direction with each coat. This acts similar to plywood, strengthening the skin. Watch for stray brush hairs between layers. It's easy to remove a hair before you dry but much harder after a few layers have dried. Also, do not use a high heat setting as it could damage the gel. However, like with any process flaw, this hot setting can be used to burn in, boil, and bubble the gel skin if that particular aesthetic is desired in the piece. Appling as few as six thin layers makes the skin very delicate and stretchable but is easy to tear. Applying as many as 12 thin layers makes the skin very thick and potentially brittle.

2. The second method is to apply a few thick coats, curing and drying between each coat. These thicker coats take a lot longer to dry and it is important to only use the cool setting on the hairdryer. Hot air could potentially damage and alter the gel with bubbles, cracks, and imperfect thicknesses. Again, this may be the desired effect; however, it is not as predictable as with thinner layers of gel.

3. The third method is to apply a single, very thick coat using a palette knife to glop the gel down on one side and distribute the gel across the image in two or three soft-handed strokes. The gel will even slightly but this method could be used to get some heavy textures on the surface similar to encaustic/wax work. Typically, it will require 8–10 hours for thicker applications to dry. When using this method, several images can be prepared for transfer and coated at once, letting them dry and cure overnight to full transparency. Another issue with this method is that dust and hairs can settle into the gel before drying.

4. There are many other variations and they can be discovered through experimentation. A successful starting point would

SPECIAL NOTE

· · · · · · · · · · · · · · · ·

When using a hairdryer, do not cure the gel with the paper lying flat on a stiff surface for too long as it could create moisture pockets or "sweat" on the underside of the paper. Instead, hold up one corner or side of the paper or use your hand to hold the paper from underneath carefully while drying the print. Don't use too high of a setting or your print can go flying and pick up all kinds of unwanted textures and debris if it falls on its face. Not drying it in this way could result in bubbling or a breakdown of the gel when soaked in water, as it is not fully dry. If the gel is not dry, it can turn to paste and ruin your entire image. Curing fully is the most important consideration before soaking the print for paper removal.

be eight very thin layers, alternating brush stroke direction and fully curing between each coat.

Gel alterations: a small amount of pigment can be added to the gel medium for added tonality but should be done sparingly in order to maintain transparency. Another alteration could be made by brushing on a topcoat of gel and adding in some texture and tracing elements on the image to produce depth and dimension. Using textured gel at this stage makes paper removal difficult, but some textured gels work very well as a final coat after the transfer is complete.

Before moving to the soaking stage, the image should be trimmed so that only the area image area with gel remains. If you brush past the image boundaries to begin with, you can make it becomes borderless, without paper edges.

Step 3: Soak the Print

Depending on the print size, a tray or container will be needed that can accommodate the full size of the image or more. When working small, a simple plate can be used with very little water. Be careful not to use a darkroom tray with textured bottom, you will want a tray with a flat surface in order to remove the paper without damaging the image.

Using a warm to mildly hot water temperature is best when removing the paper backing, as the fibers of the paper will soften more easily. If the water is too hot to touch, it is too hot for the transfer. Lukewarm water is preferred for comfort as well as preventing breakage, which is more common with colder water that makes the gel more brittle and snappy.

Soak the print, gel side down. The water can be seen penetrating the paper backing. If copy paper is used, the soaking time is very quick. If fine art paper is used, such as Somerset velvet or enhanced mat, soaking times will be much longer. Copy paper soaking times range from 30 seconds to two minutes.

Step 4: Release the Paper Backing
Do not rush the following.

Once the print has soaked, leave it in the water and start to gently rub the paper side in an easy motion starting in the center. The fibers of the paper will begin to pill and roll away gently. Once the first layer of the paper is removed in the center start to work from the center out to the edges, holding the print down with one hand and gently rubbing with the other. This step is extremely delicate! Be careful not to rub too hard or too much or all of the ink can be lost. It is also easy to tear and break at this stage.

You will not want to remove all of the paper like in some other methods. This process is a little more involved as only the first layer or two of paper should be removed, rinsing the print and adding new water so the pulp doesn't build up. If too much pulp is allowed to build up in the tray, it can slip under the gel layer. If this occurs, the pulp can easily remove ink from the surface of the image by incidental agitation. Again, this could be used in an intentional way for further distortions and loss of details.

Once the desired amount of paper has been removed, carefully rinse the gel image, removing undesired pills and fibers from the surface. The desired amount is subjective and open to the printmaker's discretion. As a starting point, be sure only to remove a layer or two of paper. Try to keep the paper pulp visible in the highlight areas. This will translate into a brighter highlight, especially when using darker substrates.

Step 5: Dry the Skin
Drape the gel skin over a drying rack or another smooth, non-stick surface that will allow air to dry the skin. Be careful not to allow the skin to become stuck to a surface or other paper materials as this could damage or alter the skin.

SPECIAL NOTE
.

Some surfaces, like wood,
may require a couple coats
of gel to be applied and
dried before the wet coat
for transfer. Other surfaces
will allow the print to slip
around easily. Be sure to keep
your surface in mind while
solving issues regarding the
permanence of the transfer.
For example, some wood
is highly acidic and could
affect the image over time.
Adding layers of gel on your
substrate will protect the
paper and ink.

SPECIAL NOTE
.

If a high heat setting is
used, air pockets and
bubbles may be produced
due to expansion. This is
an interesting effect but not
always desired. To avoid
them, use a very low heat
or cool setting on your
hairdryer.

Alternately, the gel skin may be dried with a hairdryer on a cool setting to accelerate the drying process. It may be draped across the hand or arm while drying, if small enough. You do not need to let it fully dry before applying it to your new surface.

Step 6: Prepare the Surface Material

Select your new substrate. Coat the substrate surface with an even amount of gel medium. This layer should not be too thick or too thin. Once again, it is difficult to describe the correct gel thickness. Experimentation will be necessary. Do not allow this layer to dry as it acts as glue between the substrate and the gel transfer. The transfer will be applied with the wet layer on your substrate.

Step 7: Apply the Gel Skin

After putting a wet layer of gel on your substrate, lay the gel skin gently on the surface with the paper side down. At this stage, purposeful stretching, folding, creasing, and ripping may be carefully done. Depending on the original coating method, the skin might be very delicate and brittle.

Use the brayer to roll out the air bubbles starting in the center and working up, then starting in the center and working down. Do this until all the air bubbles are out, unless those effects are preferred. Once the gel skin has been applied over the surface and rolled out, fold the excess over the edge of the substrate and spread some of the excess gel around the edges to act as glue.

Use a hairdryer to seal the edges, adding extra layers of gel around the edge to seal the image.

PROBLEMS AND SOLUTIONS

Some common issues can occur within the process. This section will explain why they happen, how to fix them if possible, and how to prevent them in the future. You may also choose

Figure 5.4 Brady Wilks, *Echoes with the Wind* – acrylic gel lift/transfer on wood

to intentionally create some of these effects for a particular aesthetic.

Gel Dissolves During Soaking

If the print was not cured properly before the soaking stage, the water will mix with the gel and turn it to paste. This causes the print to be destroyed when attempting to remove the paper.

To avoid this, first let the print dry thoroughly before applying gel (allow the ink to cure from the original print). Second, apply very thin coats of gel, using the hairdryer to thoroughly cure each layer. Once again, be careful not to allow moisture to build up underneath the print. It is not uncommon for some sweat to occur, so a piece of cardboard or other absorbent material can be placed underneath the print to help absorb the moisture. Alternatively, the print may simply be handheld while drying. If a single thick coat of gel is applied, wait several hours (usually overnight or longer) for the gel to fully cure.

Gel Bubbles During Soaking

If the print is placed into water that is too hot, expansion bubbling may occur between the thin coats of gel. To avoid this, use lukewarm water.

Air Bubbles and Air Pockets

If a brayer is not used to roll out the transfer, there is a risk of air bubbles and pockets being left behind. Later, as the gel is heated during the curing of the finishing layers, the heat of the hairdryer makes the air and moisture expand disallowing that area from sticking to the surface resulting in a bubble. This can be remedied by using a needle to carefully puncture the smallest hole possible and remove the air. This small puncture can then be covered with a small amount of gel medium. To prevent this problem in the future, a harder brayer may be used and proper pressure applied. Be patient and spend a few extra moments rolling out the bubbles.

Micro-Bubbles During Cure Times

Small heat-bubbles can appear when the gel medium is applied too thin and the heat setting of the hairdryer is too high. The gel can be heated to a point of boiling expansion if not monitored carefully. This problem is not easily fixed and involves scraping off the gel before applying fresh coats. This can lead to damage of the image itself. It also can be used as a creative tool for added texture, depth, and dimension.

5.2 Wet Inkjet Transfers

A digital inkjet wet transfer print provides a look that no other process can achieve. Due to the variations that an artist can use to manipulate the print and its unique visual aesthetic, this alternative photographic process is a powerful and viable option for an artist's expression.

The process is simple and your supply list is short. You will need an inkjet printer; wax paper or a pack of printer labels (address, CD, etc.); matte, enhanced matte, or double weight paper (any paper without a pearl or gloss finish is best); and a bone folder (pen caps, letter openers, or small polished stones can work as well). You may also choose to use big heavy books to press evenly across the entire image.

An alternative substrate option includes paper with a specific moisture content to receive the ink in a way that bleeds together, as opposed to remaining as little droplets. The moisture content of the paper varies the nature of the transfer. You may increase the moisture content of the paper by pre-soaking or by placing the paper in contact with a wet sheet of paper. Additionally, water may be applied to the surface of the paper with a foam brush or mister.

Step 1: Prepare your matte paper substrate by having it laid out on a flat surface with the print side facing up. Have your rubbing tool at the ready.

Step 2: Take a sheet of labels and remove all of the stickers while trying to maintain the integrity of the waxy paper backing. If you remove the labels too strongly, you could rip, bend, or distort the waxy side. This will interrupt a smooth transfer. (Intentionally damaging or folding the waxy paper is also used creatively as an alternative.)

Figure 5.5 Brady Wilks, *Olga* – digital inkjet wet transfer

Step 3: Load that sheet of paper into your printer so that the ink will be applied to the waxy or shiny side of the paper.

Step 4: Prepare your image using Photoshop or other editing software and edit the image so that it is at least 300dpi with the intended dimensions you want to print. Try printing something small around 5 × 7 @ 360dpi so you can transfer it to an 8.5 × 11 sheet easily with a larger border. This will give you handling room and limit the print size. It is also more forgiving when it comes to borders and even spaces between the paper's edge and the transfer's edge. If you do not have experience printing, please refer to tutorials abundantly found online or in other platforms to give you the specifics on preparing an image for print. The idea is that you want to set up your print so that it gives you a high-quality image that you would normally make otherwise.

Step 5: Print your image.

Step 6: Once it is done, carefully hold the print by its edges. The ink will be very wet and can easily smudge. Turn it upside down carefully, positioning the print over your ready-placed paper substrate. Set down gently at the center and press. You will want to make your transfer soon after it finishes printing, so be ready with your substrate. Using a heavy book could help with the pressing. If you want a solid transfer then the use of a press is an option. Some prefer the following burnishing or rubbing step as an alternative.

Step 7: Optional rubbing – be sure to hold the print down firmly while using your bone folder or rubbing tool. If you move the paper around, the print will alter and potentially smear. (Intentionally smearing the print could also be used creatively.)

Step 8: Once you are finished pressing or rubbing, you will remove the waxy paper; wipe it off with a damp rag or paper

towel for another use. For consistency, the use of a new sheet for every print is suggested. For practicing you may reuse your sheets as long as you can maintain the integrity of the surface.

Let your new print dry face-up. If using moistened substrate paper, allow your sheet to dry between blotter papers or on a drying rack. To avoid curling, the use of a hot press is suitable.

CHARACTERISTICS

Micro-Drops and Color Pools
Due to the nature of the paper and ink from the printer, the image produced is a series of micro-spheres of ink. The waxy paper cannot absorb the ink so the result is millions of little dots varying in size and color depending on your image, its color, and the density of the ink. This results in a transfer made of up millions of little dots mirroring the effect of the wax paper. This can further be manipulated with the following aesthetic decisions.

Pressing
This aesthetic choice allows you to control the density of the ink being transferred. The harder you press the more ink will be absorbed into your substrate from the wax print. Pressing in patterns on certain areas can produce textural effects reminiscent of fabric, or illustrations. Use large heavy books to press evenly, but be careful not to move your paper.

Relief Structure
This aesthetic choice comes from three methods. First, is to reduce pressing in certain areas so that minimal ink is transferred. Second, removing ink from the wax paper before transfer (very difficult as you are pressed for time and likely to smear). Third, is to crumple up the wax paper and flatten it out again before printing to it. The creases and folds will disallow ink to transfer with the same density.

NOTE
.
This is a reverse of the image; doing it this way celebrates the aesthetic found in the transfers of old. If you choose to correct the reversal, you may first flip the image in Photoshop or another editing software before printing.

Folding

You may choose to fold and tape your wax paper before printing, disallowing the ink to be placed in certain areas. When unfolded there will be a gap in the image. Certain small folds can produce interesting patterns or add psychological depth to the narrative of the piece. Any of these techniques can, but this is the most obvious.

Warning: Changing the thickness of your paper could affect your printer by smearing ink on the print heads and other areas.

Illustrating with the Rubbing Tool

Using the rubbing tool as a pen can produce various illustrative qualities and concepts. You can create textured backgrounds, enhance the subject's lines or even inscribe messages into your work. The results are varied so practice with test sheets first before making full size prints.

Label Patterns

You may choose specific labels and brands in order to produce a series of lines and shapes matching that of the cut labels. When the labels are cut, some brands have depressions or perforations in the backing. This will translate as a loss of ink. Virtually no ink resides in those depressions and certainly won't transfer. The result is a series of white lines or shapes matching the label shapes.

EXAMPLES

Figure 5.5

This print, shown above at the beginning of the tutorial, makes use of a few aesthetic choices. First, the paper was crumpled heavy in a few places as seen by the swooshing, curved, white areas on the print. Second, a rubbing tool was used to swipe downward on the background creating perceived folds in a cloth backdrop. The original image is a solid paper with no texture. The third choice was to not press in certain areas

creating a highlight of sorts seen in the left and right sides of the background.

Figure 5.6

I first folded the wax paper at an odd angle and taped it at the edge to hold it down. I kept one side of the paper untaped so there would be some dimension to the paper, causing some of the ink to smear. What you get is a small portion of the image, disjointed from the whole, and there is a violent kind of smear where the edge of the paper was folded. After removing the tape, I carefully made my transfer, pressing the entire image with a few rubbing illustrations in the hair and backdrop. No other techniques were used with this image.

Figure 5.7

This example is a straight transfer with no crumpling and no extra rubbing. I used a stack of books to press the ink in evenly. This example shows off the aesthetic choice of label type and brand. This brand of CD labels had a perforated edge in the middle and a clear punch mark from the die cutter. You can see the circles in the top right and bottom left corners, as well as the side labels in the top left and bottom right, which are vertical and straight. You can also see the perforated centerline. The trick here is to create an image within a file that will print exactly where you want the lines from the wax paper to be placed.

Experiment first, but then try to master each step and use the "randomness" intentionally.

5.3 Contact Paper and Tape Adhesive Transfers

Contact paper adhesive, tape, and other adhesives can be used to transfer images. Much like the techniques used upwards of

Figure 5.6 Brady Wilks: *Olga* – digital inkjet wet transfer

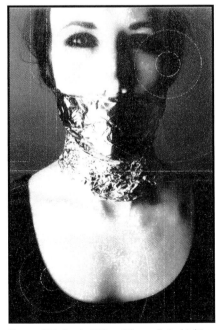

Figure 5.7 Brady Wilks, *Olga* – digital inkjet wet transfer

several decades, you can place your image face down onto your adhesive. Once pressed firmly and burnished, you can use water to remove the back of the image in layers, letting it dry and removing more little by little for ultimate control of the density and the veil of paper left behind.

Acrylic gel medium is used in this way for a very basic transfer form. Using gel to act as glue and placing your image face down on a surface with gel. Once dry, you remove the paper with water. It is the same principal with tapes.

TAPE AND CLEAR CONTACT PAPER TRANSFER

Step 1: Prepare and produce and inkjet print to be used either as a single image or prepare multiple images for collage.

Step 2: Place tape on your image or use contact paper to cover your image. You may also choose to lay the contact paper sticky side up and place your image face down.

Step 3: Use a burnishing tool like a bone folder or spoon to press the tape into the image, trying to remove bubbles and ensure a good contact with the adhesive.

Step 4: Turn the print over and use small amounts of water to dampen the back and begin to remove the paper gently. Remove layer by layer and be careful not to be too forceful or else you will remove ink as well.

Step 5: After drying it to make sure the desired paper has been removed, you may either tape the back side to seal the ink or incorporate it into another project or process. Alternatives in presentation include backing the transfer with tracing paper and creating a box with a light inside to illuminate your photograph like a light box. You might also choose to keep them two-sided and hang them like fabric.

MATERIALS

- Clear contact paper or clear packing tape
- Inkjet prints
- Scissors
- Pan for water or spray bottle
- Water

5.4 Other Wet Material Transfers and Lifts

The following are brief overviews and descriptions with print examples to give you an idea of what is available. There are many great teachers, books, and workshops to help you with specifics but know that they exist and find the one that you like best.

SOLVENT TRANSFERS

The idea of a solvent transfer is to make a toner-based copy or laser print (inkjet prints may not work well with solvents). The artist should then place the print face down on a substrate such as a fine art paper. Tape the two down at the top so that as you transfer, you can check your progress without the paper slipping.

In order to transfer the toner to the receiving substrate, you must use some kind of solvent and burnish (rub) the image for the transfer to work. Some artists use solvents like Xylene or wintergreen oil. These materials require caution when using. You should follow the warnings and proper handling guidelines of the materials with care. Ventilation, gloves, and other precautions are suggested. Respiratory masks are required if you have sensitivities to the fumes but, either way, ventilation is required.

Other artists use what is called a blender pen. This pen might contain a chemical that is Xylene or similar to it. Ventilation is still required. These pens are easy to use but might be more expensive in the long run. Experiment carefully and find the solvent that works best for your circumstances.

Use the solvent or pen and work the back of the image little by little and pause to burnish the moistened area with a bone

Figure 5.8a Solvent transfer to matte paper

Figure 5.8b Solvent transfer to antique paper

folder or spoon. If taped down properly, you can lift the image and check your progress, and then you can continue on. Do not use too much solvent or the print might bleed. You might also find that freshly printed copies or laser prints don't work as well as those that have set for several hours or even a day.

STUCCO AND FRESCO

Similar to traditional acrylic gel transfers, an artist may use a paste-like paint, stucco, or other similar materials. The specifics are different but the general process is to apply the wet material to a substrate and, while it is wet, place your image face down, let it dry, and then remove the paper backing. The

other variation, of course, is to apply the mixture directly to the image, let it dry, and remove the paper back afterwards.

One example of this is from artist Beth Devillier. She has devised her own working methods using a medium with stucco and, instead of putting the image face down on a wet base, she puts the fresco on the surface of the print. She then builds it up with more stucco and allows it to dry over a couple days before removing the paper with water. As it dries the surface changes giving it a textural aesthetic that the artist prefers. Instead of the image resting on top of the surface, it has almost become part of the plaster mixture, much like a fresco painting might look. Beautiful examples of this can be seen in her images titled *Whisper Lovely* and *Lost Transcendence*.

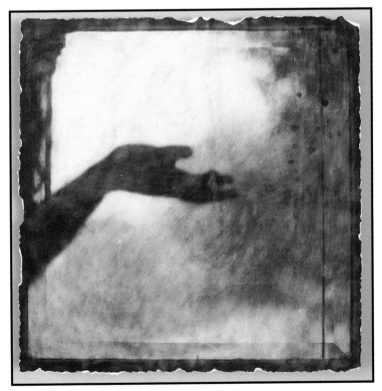

Figure 5.9 Beth Devillier, *Whisper Lovely*

Figure 5.10 Beth Devillier, *Lost Transcendence*

DIGITAL ART STUDIO SEMINARS

Bonny Pierce Lhotka started Digital Art Studio Seminars and has created various methods for digital printmaking since the 1990s. She has a number of books, DVDs, and art materials such as Transfer Films and SuperSauce for transferring images and other materials.

The general idea is to use an inkjet printer to print to the transfer film. Then apply the SuperSauce to a substrate, lay the image face down, press and peel back the film. You can get full details from her process on her website, in print, and on DVD. Image details seen in Figure 5.11a and 5.11b.

WET PLATE COLLODION TRANSFER

In 1851, Frederick Scott Archer adopted a material previously used as a medical dressing, called collodion, to be used with light sensitive materials on a base. Known as wet plate collodion, this process made photographic positives and negatives on

Figure 5.11a An example of the film being lifted off after transfer

Figure 5.11b Bonny Pierce Lhotka, *Time Stops*

glass and metal plates. Sometimes they are loosely referred to as ambrotypes and tintypes respectively.

Additionally, Archer wanted to save money by reusing the glass substrate for making plates. He devised methods using a material much like rubber cement to actually transfer the image to paper. The paper would then be used for other photographic print processes while the original substrate would be cleaned and reused. This process didn't really take off but that isn't to say that any artist working with wet plate collodion today can't also try the unique aesthetic of transferring collodion to other surfaces.

COLLODION CHLORIDE PRINTING OUT PAPER

Similar to the chemistry used in wet plate collodion is the collodion chloride printing out paper process. There are theories for coating a specific substrate, printing out a contact image over many minutes and then, while processing through the wash, tone, fix, and final wash, you can remove the collodion chloride skin from the one substrate and move it to

Figure 5.12 Taken during private instruction with France Scully Osterman in her skylight studio, printed to collodion chloride printing out paper – unfixed

another. Finding the right substrate is difficult because it needs to be able to separate from the collodion chloride skin, but in a way that is controllably placed on another surface.

CARBON TRANSFER

Carbon transfer is a favorite among those who appreciate beautiful tonal range. I strongly suggest taking a workshop to learn this process. When done correctly, it produces one of the most beautiful prints or transfers. Essentially, you make a tissue, sensitize and dry the tissue. Using a negative in contact with the emulsion side, you expose it with a UV light source.

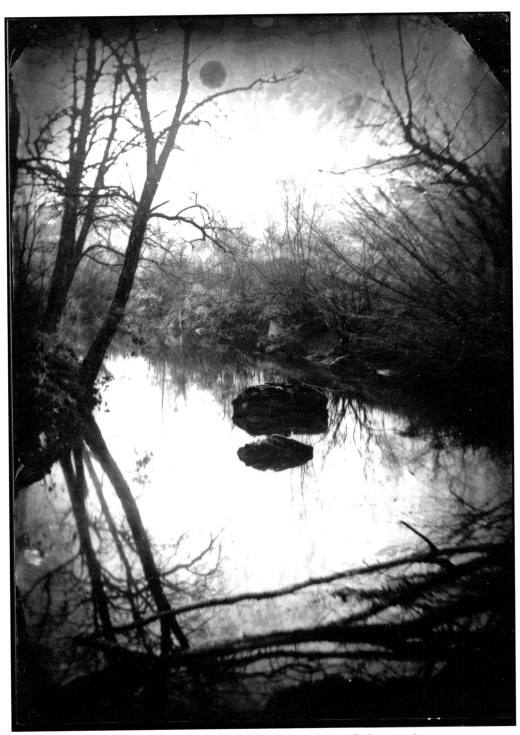

Figure 5.13 Borut Peterlin, *Susica River* – carbon transfer from wet plate collodion negative

SPECIAL NOTE

.

I strongly suggest taking a workshop for a number of the processes listed in this book. For wet plate collodion, ambrotypes, tintypes, dryplate, collodion chloride POP, photogenic drawings, carbon transfer, and a number of other incredible alternative and historical processes, please consider Mark Osterman and Nick Brandreth at the George Eastman House Workshops in Rochester NY.

There are other great learning centers that host artists and instructors who teach alternative process basics such as Maine Media Workshops, Santa Fe Workshops, Penland School of Crafts, Anderson Ranch, Center for Alternative Processes in NY and a number of other places. Learn how to do it all correctly first from the best, then take the process to places your art requires or demands.

After you have made an exposure, remove the tissue and soak it in water while placing it on a final support or temporary support. Then cover it with a blotter and let it set for a while. Another bath of warm water is used to remove the insoluble gelatin and, should you decide to transfer it again, you can let the image dry on the temporary support, transferring it to a final support afterwards.

POLAROID LIFTS

Similar to the aesthetics of an acrylic lift, the Polaroid lift is done using hot water to release the film from the original base and transfer it to a new base while in the water. It is very thin and like a veil so you can brush it, rip it, fold it, or layer many lifts together. Resources can be found online, including instructions provided by Impossible Project, the company that is reproducing instant film from Polaroid's original equipment.

6

CHAPTER 6

Print and Image Manipulation

A piece of photographic art doesn't always end with the print. There are a series of print and image manipulations that can be done to further transform your image, add a different level of depth, or add more narrative to an otherwise ordinary image. For example, a traditional portrait is usually perceived as a depictive image of a person. Folding or distorting the face might start injecting a sense of psychosis, fractured identity, or angst. It is, of course, up to the artist to know why they are making the art, but having a wide spectrum of possible outcomes can help the artist find not only an aesthetic style, but a refined concept as well. The following are a few examples of these manipulations.

6.1 Folded Prints

MATERIALS

- Various papers for testing weight and fold characteristics
- Brayer, roller, or something to press the folds flat such as a large metal spoon
- Staples, tacks, glue, tape, or any material that will hold the folds down

After printing your image, you can transform it even further through paper folding, bending, and making your once two-dimensional image into a 3D piece of art. This is also covered in different ways in Chapter 9.

First, experiment by printing your image onto different paper mediums and find which best suits the kind of fold you would like in your work. A thick, heavy, ultra-premium gloss inkjet paper might not be thin enough to fold easily. Tracing paper might be too thin. Start first with a print on regular typing or copy paper. Start small so that you don't waste materials.

Second, after the print is dry, begin to fold or crease it by using a brayer, your fingernail or another hard object to smooth out the folds and wrinkles.

Third, you may need to adhere the folds to keep them in place or to fix them as your final presentation. Some artists use staples, tacks, safety pins, thread, tape, wax, glue, or other materials to hold down the folds, keeping them more flat than dimensional. You can take a mathematical approach and create geometric folds, altering the image. An Origami-style approach will allow you to make folds creating known objects. You can also print images and use them to create a 3D object by folding and assembling. These are covered in more detail in Chapter 9.

Additionally you can crumple the paper in a more violent way. The paper is folded over onto itself and pressed with a brayer or other creasing tool to distort and fracture the original imagery.

6.2 Assemblages, Fractured Composites, and Irregular Borders

Many of the processes mentioned in this book crossover to other chapters because they might be 3D or borrow techniques and approaches from similar processes. We talk about collage in the next chapter but assemblage shares some of the same principles as collage work. Assemblage usually relates more to found objects or materials assembled to create a piece of art. This can include found photographs and other objects, which can be assembled and integrated into a single piece of work.

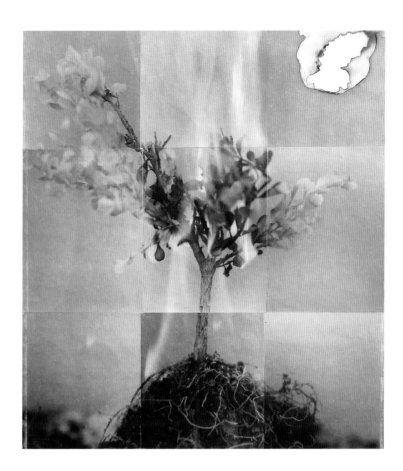

Figure 6.1 Charles Grogg, *Victory* – 9 platinum/palladium print panels, sewn, burnt, soot, 29 × 36in

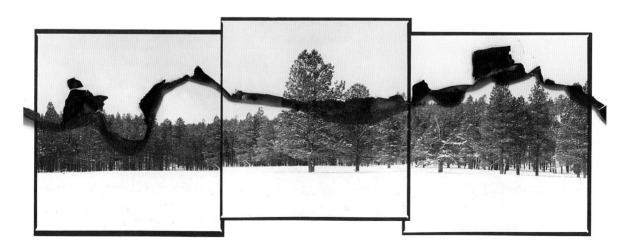

Figure 6.2 Charles Grogg, *Regrowth* – digital print over platinum/palladium, burned paper, soot, 17 × 51in

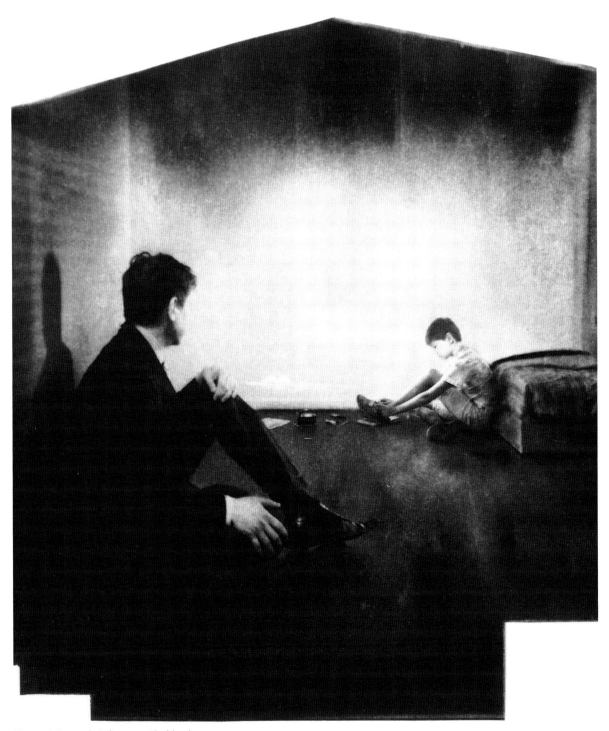

Figure 6.3 Jonah Calinawan, *Flashback* – cyanotype

Another variation is to make several photographic art objects, such as transfers on blocks of wood or other found objects, and assemble them into a more dimensional configuration.

Some artists don't worry about integrating images together and instead stack or align work in grids, assembling multiple exposures together to create a single image. This might be done due to printing size limitations, but it might also be the artist's intent to emphasize the space between the images and/or the way they are assembled as a manner of injecting more meaning rather than only being a vehicle for presentation.

Furthermore, an artist may use irregular borders, not only to be different than standard presentations but also to emphasize or accentuate a certain part of the imagery, making it a necessity as opposed to a gimmick.

6.3 Sewing, Threading, and Embroidery

With the use of thread and needles, an artist might choose to alter their image in a way few other processes can. Markers and paint might be used in a similar way to alter the image, but thread creates a texture, rhythm, and visual effect that hand-coloring cannot produce, especially depending on the choice of thread, yarn, or other fibers.

Start with an idea in mind. Then, using a thread and needle, puncture the print from the back side and tape off the end of the thread flat against the back of the page. This eliminates the need for a knot that could potentially rip through. If you have sewing or embroidery experience you might find this an easy task. Take on using complex patterns and varied colors to see how it shifts and transforms the image.

MATERIALS

- Paper prints
- Thread (various colors/materials)
- Needles
- Tape to hold the thread start/end

6.4 Staining

COFFEE STAINING

Fill a coffee cup halfway with water and add 2–4 tablespoons of instant coffee crystals. Brush on with a foam brush wet enough to cover but not soak the paper. The way you apply, stain, and remove the stain will all affect the final result. Practice with test paper before staining an actual print. Take caution not to damage the paper so that it doesn't rip or tear due to too much moisture.

An additional option is to place wet sheets between plastic wrap, wax paper, or glassine-like materials. This can add a texture pattern to the stain while it dries.

ACIDIC TONING

Lemon or lime juice and a heat gun or hairdryer can be used to create a burned look. Dip the paper edges into the juice and heat. The more heat that is applied, the darker the effect becomes. Always practice on test paper first.

6.5 Solvent Blotting

Solvents are traditionally used to transfer images from one surface to another, but when working with laser or Xerox prints you can also use solvents to spread around the media without transferring. With heavy amounts of solvents you can actually lift the ink off, spread the ink around and use other manipulations to alter the image as it sits on the original print.

Figure 6.4 Brady Wilks, *Untitled* – solvent blotted laser print

6.6 Hand-Coloring, Tinting, and Burnishing

There are a number of ways to alter a photographic print or one-of-a-kind image on various surfaces. A popular combination is to apply markers or various paints directly on the print, much like the two examples in Figure 6.5.

Through use of somewhat translucent markers, color is applied to alter the otherwise black and white print. This can also be done on most paper-based prints as long as there are no resist materials such as wax or oil. Jill Enfield has wonderful examples of what is possible with hand-colored images.

Another form of hand-coloring comes through the use of pigments and in the case of wet plate collodion, burnishing as well. Mark Osterman has a perfect example of both in his image titled *Spilled Tea*. He delicately burnishes the metal subjects following the contours of the objects. This forces the silver to lay down, causing a more silvery look to the otherwise warmer tone of the wet plate collodion positive. He also uses a careful mix of pigment dust to apply to other areas in the image. In this case he uses multiple colors and their compliments, further enriching the image before varnishing.

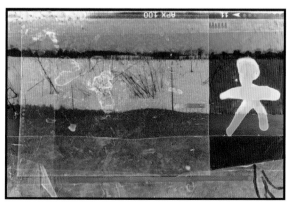 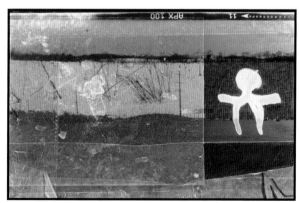

Figure 6.5 These two images are first made using a combination of film negatives and photogram style materials to produce silver gelatin prints. They are then hand-colored with markers and paint pens in sequence.

Figure 6.6 Mark Osterman, *Spilled Tea* – burnished and tinted wet plate collodion positive on glass.

6.7 Distressing

Distressing or adding texture to a print can be as simple as damaging it. Laying the print on a pavement and running it over with a car is one of a hundred examples of possible ways to distress your work. There is no limitation on what you can use to distress your images, be it sharp objects for scratching the surface, pressure for adding texture, flame burning the edges, or a dozen other types of distressing. Here are some specific ideas.

FADED IMAGE

A wonderful way to give an image an aged and faded look is through the use of a fine grit sanding foam-block or a fine grade steel wool. If you are going to use sandpaper, make sure it is a fine grit like 220 through 600. Make tests before you commit to a real print. Figure out the amount of pressure and motion you need to use when sanding the print so that you do not necessarily see the evidence of sandpaper marks. That is not to say you can't forcefully use the materials to make heavy-handed marks, but for the sake of making an image look old and faded, you will want a combination that provides and even and smooth result. Some print types and finishes might not look good with this technique, so try a sample before approaching the real piece.

For a heavy-handed look, or a true manipulation of an appropriated image, consider using sandpaper on old photographic prints. In Figure 6.7, a course sandpaper was used to remove most of the photo information in the head and torso.

ROUGH EDGES

After making a print, you may choose to use a large metal ruler or ripping bar to tear of edges of your print, making a rough

fibrous edge. This works best with paper that is thick and has a matte finish, so that any coating doesn't flake or peel off. The ideal situation would be to make an inkjet print with a few inches of white border on a velvet, fine art paper. After the print is made, use a metal ruler or ripping bar to align it so that it is parallel to the print edge. Hold the ruler down firmly and

Figure 6.7 Brady Wilks, *One of the Faceless* – appropriated family photo, sanded

SPECIAL NOTE

· · · · · · · · · · · · · · · · · · ·

If your print image is face down and you are pulling up to rip, there will be fewer white edges. If your print is face up and you are pulling up on the rip, there will be more white areas due to the nature of the paper fibers. Some results may vary.

close to the area of the print that you are ripping. Slowly and steadily rip the paper, adjusting your hold so that nothing slips.

WATER DAMAGE

Depending on your printed materials, you can use water to alter the image surface creating various distortions. On some matte finish or velvet, fine art papers, dropping water on a fresh print will cause the ink to bleed around a bit resembling water color or solvent blotting.

7

CHAPTER 7

Appropriated Art, Collage, and Cameraless Imaging

7.1 Photo Collage

Photo collage has a rich history of artists using photographs and other materials in various ways to put together images as a single piece of art. There are specific styles and many of them cross over to other processes.

Some artists make photographs, using them like paint and collaging a larger narrative out of many parts. As an example, they might go out into nature and photograph various tree textures, flowers, landscape scenes, and other objects. They use those photographs and manipulate them digitally, making

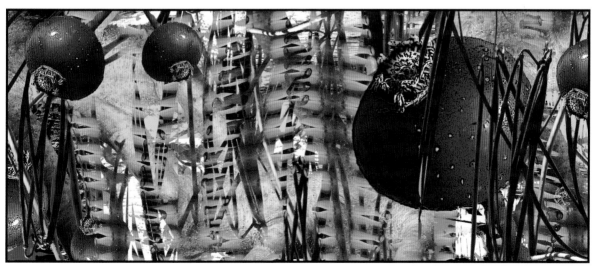

Figure 7.1 Lisa Sheirer, *Pop Garden*

Figure 7.2 Bea Nettles, *North* – one of 4 booklets housed in a slipcase from the series titled *Place*

a collage with software or they might print them and work on a more physical level with something adhesive.

Lisa Sheirer uses digital photographs as the base and inspiration for much of her art. Transforming the work into vector art is an important step for some of her work. It allows her to print very large.

Another example of photo collage comes from Bea Nettles, who uses photographs of names found on tombstones and not only creates a collage but also constructs poetry, using the names as words. Not only is there a bit of chance involved in finding a name, but there is also an active search for certain names as well.

Some collage artists use their own or other's photographs, perhaps from a magazine, and transform them into something else. One of the best examples of this I have seen is the work of Joe Mills. His earlier collage work was created using magazine clippings and applying them to found objects for substrates.

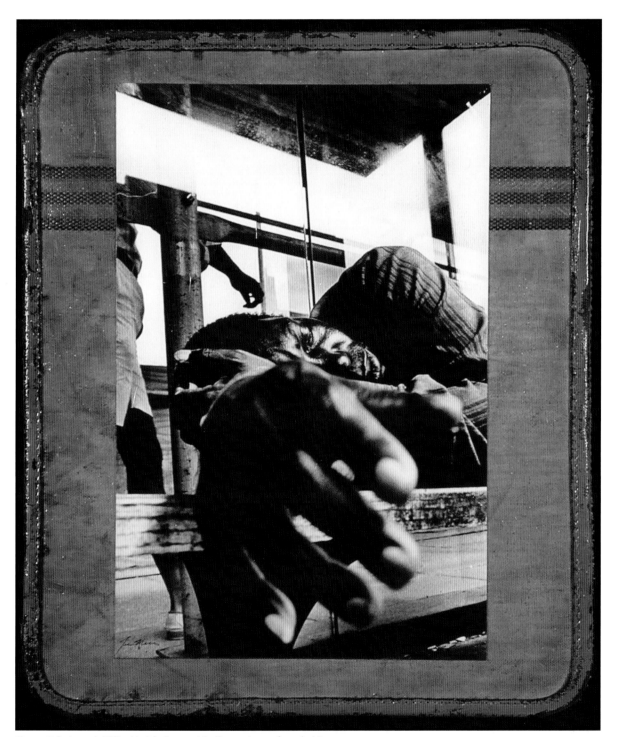

Figure 7.3 Joseph Mills, *Untitled* – varnish silver print on found objects

Other work was made using his own photographs. This work is varnish silver on found objects.

7.2 Finding and Manipulating Old Photos

Finding old photographs can provide great material for those artists who choose to alter something that already exists. There are some who alter and manipulate the existing photographs with distressing techniques, hand-coloring and other manipulations. Others scan the images and use things like the texture of the paper, the tone of the print, the photo studio logo, or other elements commonly found on old photographs. Good examples can be found on cabinet cards or other prints such as carte de visites.

These photographic objects have a heavy paper base with an inset photo created using various processes such as collodion chloride, albumen, and others. They also sometimes include a signature or logo stamp of the photographic studio or maker of the print, either in the corner or along the base of the card in its own blocked out area. Furthermore, the maker's logo or signature, sometimes accompanied by ornate illustrations, are printed on the back.

Some artists scan these objects to save those unique characteristics as a base for art making. For example, Edward Bateman creates amazing constructs made up of 3D designed subjects incorporated into the aesthetic and style of these period-specific cabinet cards, making it look like a photograph of a robot, automaton, or spectral device from the late 1800s. The paper's edge, the tone, the photographic studio, even the cracks and imperfections of the original print are all considered when making this kind of art.

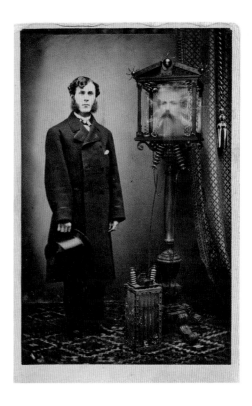

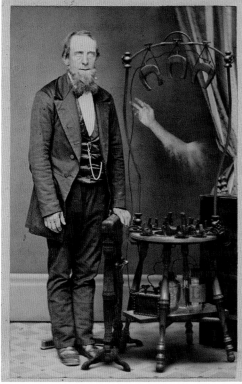

Figure 7.4 Edward Bateman, *Spectral Device No.4*, *No.7*, and *No.8* respectively, from his *Science Rends the Veil* series, a total collection of 16 images

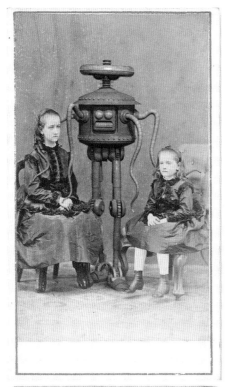

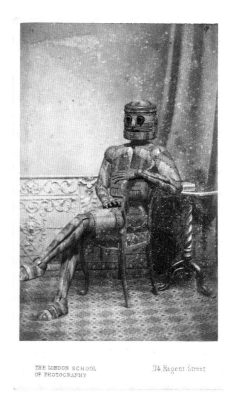

THE LONDON SCHOOL OF PHOTOGRAPHY 174 Regent Street

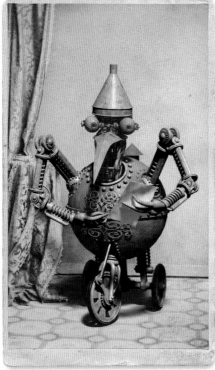

Figure 7.5 Edward Bateman, *Carte De Visites No.13, No.18,* and *No.21* respectively, from his *Mechanical Brides of the Uncanny* series, a collection of 21 two-sided cards

7.3 Incorporating Photographs Into Collage

This type of collage is different than photo collage, where the emphasis of art making is for the transformation to happen to the photograph. In this case, some artists rely on photographs to add narrative or substance to their collage work but the emphasis isn't necessarily within photography. They might also incorporate company logos, illustrations, graphic design, text, book pages, buttons, and a number of other materials for their narrative.

The difference here is that the photographic image is transforming the collage as opposed to a process transforming the photographic image. In this case, it is a matter of priority and the photographs are just a part of the whole.

An example of traditional collage work comes from Julie Maynard, who works with a number of materials from appropriated photography and magazine clippings, to found objects.

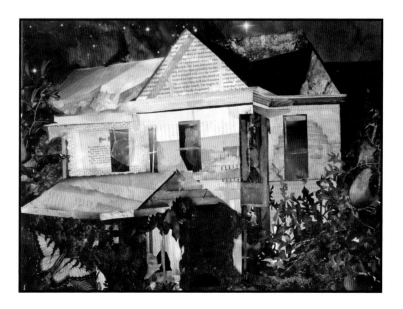

Figure 7.6 Julie Maynard, *Almost House –* collage

7.4 Chemigrams

A chemigram is a loosely used word to generically describe an image that has been made with various combinations of light-sensitive materials, light, objects, and chemicals for processing and effect. The photogram is a very common process in which cameraless images are made using a sensitized substrate and various objects to selectively block light. When processed, the resulting image reveals the characteristics of the chosen objects' shape and transparency. A chemigram is a little different. Instead of using objects, the applications of chemicals are emphasized.

Depending on the chemicals, their application, light, and processing, the end result will vary. Here are a few examples of how chemigrams are made with specific processes.

Figure 7.7 Brady Wilks, *Ideas Within Plate 04 – wet plate collodion chemigram*

WET PLATE COLLODION CHEMIGRAMS AND PROCESS CHARACTERISTICS

Previous knowledge of wet plate collodion is required including the safe use of associated equipment. See the Resources section of this book for information on getting started with workshops, chemistry, and associated equipment. Some of the following steps and examples are not exclusive to cameraless imaging.

1. In a darkroom, portable darkbox, or converted fishing tent, start by pouring your collodion onto your plate, let it set up, and then sensitize the plate.
2. After removing the plate from the silver bath you can use light from a source such as a flashlight, phone, or other device. Note that red light, red laser, or even some yellow lights might not be strong enough due to the insensitivity of the process to that color spectrum. The process is most sensitive to blue and UV light. Use the light to expose the plate.

Figure 7.8 Brady Wilks, *Ideas Within Plate 02 – wet plate collodion chemigram*

3. Use developer then wash thoroughly before fixing.
4. Repeat the above steps with any combination of the following for different effects.

DOUBLE POURS

Pour collodion and let it set up. Pour the collodion a second time in a smaller or varied way, creating a different shape with the collodion pool. These differences will alter other steps including sensitizing and development. Some areas of the collodion may dry, especially those areas on the first pour. Starving the plate (using too little collodion) can cause similar issues, where the plate dries before entering the silver bath. In the case of the following image, the first pour covered the entire plate, allowing it to set. Then a second pour, with an arched window but used in reverse so that the arched window was at the base.

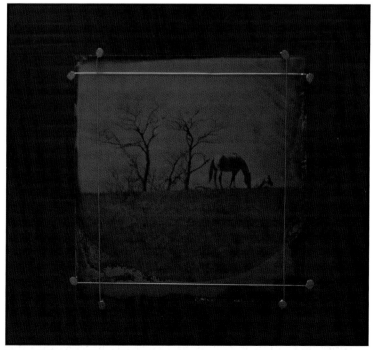

Figure 7.9 Brady Wilks, *Shadow Grazers* – wet plate collodion contact positive on glass

DIRTY POUR

If you have collodion that has precipitate at the bottom, this sludgy otherwise unusable part of collodion can be put to creative use. This precipitate will cause flaws, sometimes textural, on the plate.

FAST POUR OFF

You can pour off the collodion in a straight up and fast way, creating something referred to as crepe lines. It can look like a mesh or web and is usually considered a problem. To fix this, people will pour a good amount of collodion and when they pour it off, they evenly rock the plate, filling in those lines while slowly bringing the plate upright. Instead, you can use this creatively by not rocking the plate and by bringing it upright quickly. The collodion will run off straight to the corner, hopefully causing heavy crepe lines.

INTRODUCING CONTAMINANTS

Contaminants can frustrate any wet plate collodion artist. These can be used selectively and intentionally to create wonderful effects for your chemigrams. After pouring collodion, you can sprinkle the surface with organic matter like dust before sensitizing it. Depending on the material, you can create little black voids, spots referred to as comets, and other variations. Additionally, you can intentionally introduce fixer on the plate by touching the edges with gloves that have touched fixer. It is important to experiment in a number of different ways. It is even more important to do a little research into the nature of the chemicals and how they react and interact. This understanding will allow you to make not only perfect plates, but plates with controlled flaws.

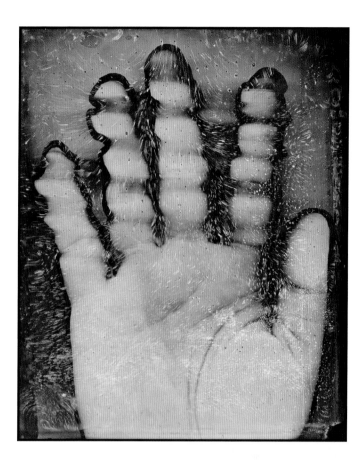

Figure 7.10 Brady Wilks, *Untitled* – wet plate collodion contact positive on glass: the artifacts, sometimes referred to as comets, are made up of dried silver and other organic matters stuck on the transparency film and applied to the newly sensitized plate before exposure

SELECTIVE SENSITIZING

After pouring your collodion, you can use a dropper or syringe to selectively apply the silver nitrate solution. Normally, if you don't dunk your plate in a smooth, even fashion, you will wind up with lines or variations in the sensitizing outcome. Use this to your advantage by first creating a pattern of droplets or other shapes and then, after a few seconds of sensitizing, place the whole plate into the bath.

SELECTIVE LIGHT

Using small lights can allow you to make hot spots or gradients of dense silver areas that fade and reveal more of the substrate. Cell phones, flashlight apps, flashlights, and other small light

sources will produce different results in exposure. If you want an even exposure without any hotspots, simply turn your darkroom lights on or exit your darkbox for a moment holding the plate. Then you can rely more on your other steps to produce your alterations in shape and exposure.

SELECTIVE DEVELOPER

Sometimes artists pour their developer in a way that misses some areas or splashes. Do this creatively by applying developer with a dropper or intentionally leave some areas undeveloped. Variations include slowly but steadily pouring developer on the plate in order to make the pool larger and larger until the plate is covered, or developing one part of the plate longer than another. Just know that there will be hard edges between those areas that were developed first and areas missing developer altogether.

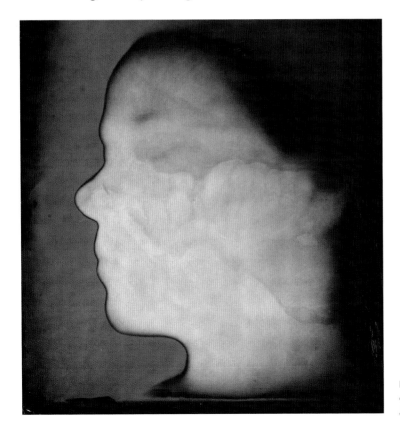

Figure 7.11 Sally Mann, *Untitled* – wet plate collodion positive on glass, courtesy of the Artist and Edwynn Houk Gallery

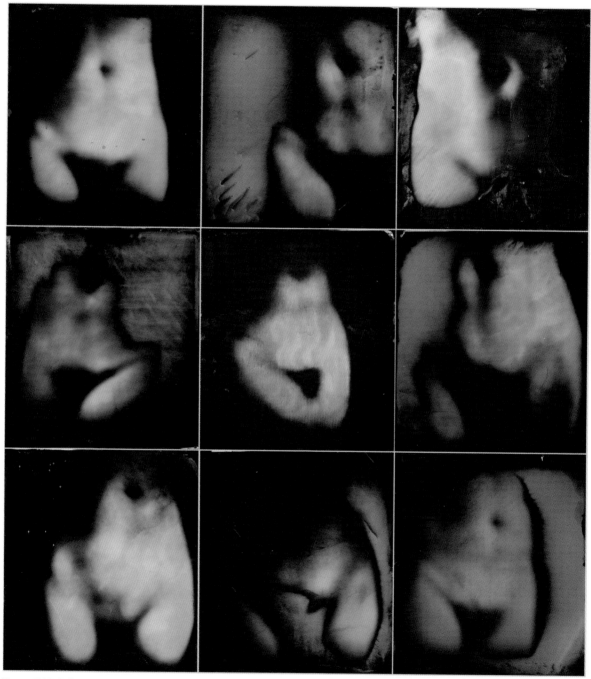

Figure 7.12 Sally Mann, *Untitled* – wet plate collodion positives on glass, courtesy of the Artist and Edwynn Houk Gallery

Combinations

You may combine as many or as few of these steps according to your intended outcome. Start with a single pour and selectively sensitize an area, followed with even light and sloppy development. This will be a good baseline to start branching out into other combos such as precipitate, dust, crepe lines, fixer contamination, and other variants. Remember, this approach is not limited to chemigrams. You can apply or embrace any number of these process conditions in a creative way.

One of the best examples of this embrace comes from the work of Sally Mann, and more recently with her self-portraits as wet plate collodion positives on large, black glass plates. Some work is shown singularly and others are joined in specific groupings ranging from grids of 3 and 9 up to 20 and 75 pieces.

SILVER GELATIN CHEMIGRAMS AND LUMEN PRINTS

You can use black and white silver gelatin photo paper in a similar way to wet plate collodion chemigrams by using selective development, light, and other materials. Silver gelatin chemigrams are made by exposing the paper to light, using resists, developing selectively, and, in some cases, time. The following instructions should get you started.

1. Expose your paper to a light source. Even regular room light for a moment is long enough to develop your print to black.
 Optional step: Use a resist material so that developer doesn't get to all parts of the image. Anything that will repel water can work, such as wax materials, cooking oils, or using an inkjet printer to print directly onto silver gelatin photo paper. The ink acts as a partial resist to the development stage. Wax crayons can also be used to draw on the print

before development. Oil-based materials can be used to coat certain areas, protecting them from developer. The most important thing to consider when using resists is washing. After you develop, you can stop the development process, but it is important to wash it before putting it into your fix. The same goes for the opposite direction. If you choose to fix first then develop, you will need to wash after each step.

2. Use developer selectively or dip the entire sheet to develop the paper. Depending on your development times you can develop for greys through blacks.
3. Stop the development.
4. Fix, wash, and dry.

LUMEN PRINTS

You can use the same silver gelatin paper to make what is referred to as a lumen print. Instead of developing an image, you use sunlight over a long period of time to expose the paper like printing out paper. Depending on your paper and the materials you use to block the light, (plant matter, fruit slices, organics, or other photogram-like objects) various muted colors will be produced. For example, some basic Ilford brand black-and-white papers print out purple where sunlight is unobstructed but orange in areas that are covered by translucent objects such as plants. The moisture content of the materials also affects the colors.

After a long exposure ranging anywhere from 15 minutes to many hours, you then skip the development stage and go straight to the fixer. Finishing with a wash like a normal print.

Additionally, if you use a resist in the chemigram version of the silver gelatin print, you can get a combination of colors and blacks. The areas you develop will go black and the area of the resist will change colors over time when exposed to

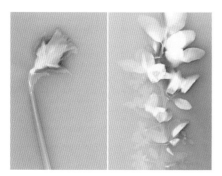

Figure 7.13 Typical lumen prints made using natural materials, sun exposure, and traditional darkroom papers such as black-and-white fiber and resin coated papers of various brands and ages. Seen larger on page 37 in Figure 2.11.

sunlight, as it would during the lumen print process before fixing.

ANTIQUE AND EXPIRED PAPERGRAMS

Some artists rely on the age and even poor handling of expired photo papers. Some artists use photo papers dating back upwards of 100 years. For example, Alison Rossiter collects various brands and conditions of antique photo paper, processing them in the hope that there is something revealed more than the expected simple fog. Whether exposed to light, water, mold, or heat, the variations and history of the paper is revealed.

Some paper can be developed to reveal certain anomalies while other papers only need to be fixed.

It is best to buy boxes of paper or even older paper packs. This way you can experiment and still have room for corrections. Sometimes the paper you buy will be nothing exciting. In fact, most of the sheets might be better used for lumen prints or creative development. Once in a while, you get a great couple of sheets, especially on the ends, where all kinds of variations can happen.

Figure 7.14 Example of expired photo papers from the early 1900s, selectively developed and fixed

You may only need or want to develop for a very short time, just long enough to see a little change. If you allow development to go too far, the print will become black and all those variations will not be seen.

8

CHAPTER 8

Waxing, Encaustic, and Resins

8.1 Waxing for Paper Negatives

NOTE

.

Refer to Chapter 10 for using wax to add a finish to prints.

In Chapter 2 we talked about using transparency film to print negatives for use with alternative photographic processes. Another option is to print negatives to regular copy paper and then apply wax so that it becomes translucent. This can be accomplished by using a block of beeswax and a hairdryer. Heat up the block on one end until it starts to melt and rub it onto the print. Once a fair amount of wax is applied, continue to use the hairdryer to melt and blow the wax around until it is thin and even over the entire print area. Other artists have used things like cooking oil, but that can go rancid over time.

8.2 Encaustics

One of the oldest forms of art, and one of the most archival, is encaustic painting. This traditional process uses pigments mixed into hot beeswax, which is then used in a similar manner to paint and is applied using special tools and brushes.

It is also a popular medium to introduce and incorporate into some photographic art. It can be used to transfer images or it can be used as an adhesive, holding the photograph to a

surface such as canvas, where layers of colored wax can be added to alter and manipulate the original capture.

Encaustics require a specific set of tools but you may find alternatives to many of them. For traditional encaustic painting, you would need an electric palette for melting the wax, a heat gun, encaustic paint cakes in various colors as well as brushes, boards, cups, and other tools.

Instead of an electric palette you can heat a pan of water on the stove and place an aluminum can full of wax chips into the heated water. The heat from the water will melt the wax in the aluminum can and this melted wax can then be used in combination with the brush to make encaustic strokes. The difficulty with this method comes in dealing with multiple colors. You would need a can for each color.

A heat gun is used to infuse or alter the surface of the wax but you can work around this by using a hairdryer instead. You should use caution using either, but a hairdryer also introduces airflow into the equation. The air pressure from a hairdryer can move the wax around in an undesirable way but, with practice, you can use the hairdryer to great effect.

It is not necessary to mix pigments with wax. You can use a block of beeswax or synthetic wax on its own, working in veiled layers over a photographic image. Use the following materials and try experimenting.

1. If you do not have a hot plate in a studio, you will need to work close to your stove. Prepare your area with some newspaper to protect your work surfaces and/or countertops. Start boiling water and create beeswax shavings with a knife. Place those chips into your aluminum can and set it in the shallow pot of boiling water.
2. Once the wax is melted, use a brush appropriately sized to match the size of your art. For example, if you are working

MATERIALS

· · · · · · · · · · · · · · · ·

- Block of beeswax
- Knife for shaving off bits of wax
- Aluminum can, cleaned out and label removed
- Pot of near boiling water
- Brushes
- Hairdryer
- A print on heavy fine art paper, transfer on wood or other process

NOTE

· · · · · · · · · · · · · · · ·

If the water level is too high, your can will not rest at the bottom and may potentially tip over.

with a 4 × 5in transfer on wood, a 1in brush should be good enough for applying the wax. Dip your brush into the melted wax and apply it to the surface of your image in a small area. After doing this 3 or 4 times, you should have enough wax on your print to shift to the hairdryer.

3. Use your hairdryer on a hot setting to melt the wax on the surface of your image. While heating the wax, use the air pressure on a medium setting to spread the wax around the surface of your image. Once you have a smooth and even layer on your image, you can distress the surface, texture it, polish it, or add more layers of wax.

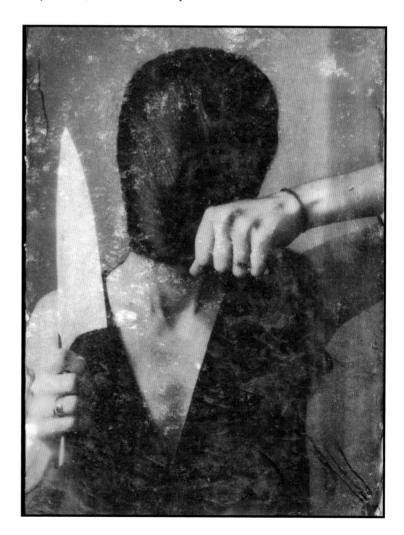

Figure 8.1 Brady Wilks, *The Faceless are Angry* – transfer on wood entombed in beeswax

Optional step: You can use colored wax to paint onto your image, taking on more of a traditional encaustic approach. Making thin layers of transparent wax in between each color layer can add a significant amount of depth to your work, much like acrylic painters might use clear coat glazes between paint layers.

Optional step: You can incorporate flat objects such as leaves, multiple images, seeds, and other small or thin objects that can be sealed into a wax layer.

4. Once you have added the amount of wax that is desired, you can cool this down in a freezer. After the wax has set and hardened you can polish the surface making it smooth and clean by burnishing it with your finger, rubbing vigorously but not too forcefully. You will quickly learn how much pressure and rubbing is needed to make a polished object.

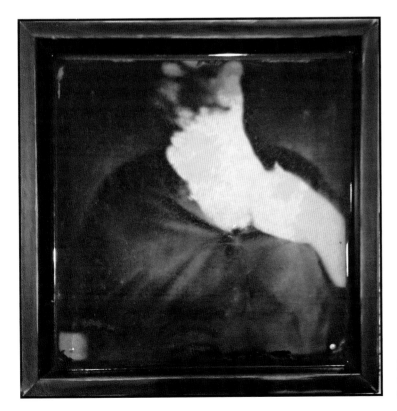

Figure 8.2 Brady Wilks, *Anxiety On My Own* –inkjet print from wet plate collodion negative entombed in resin

8.3 Entombing

Entombing is a very interesting practice and can be done with multiple materials. A photograph can be entombed in a box or other container by placing the image at the bottom of the container and pouring a material over it that will dry clear or mostly clear. This can be accomplished by using a transparent wax, acrylic gel, resins, and clear coat lacquers.

When using wax, you may have to settle on a much thinner entombment than other materials because even translucent wax has some clouding. When using an acrylic gel, like a high gloss, it will take a long time to dry and may not dry completely transparent without some change in tonality. Resins might also change the tonality but many of these products are so clear that they can resemble water or glass. As mentioned many times throughout this book, if permanence is a concern you will need to understand how the materials change over time. Wax and encaustics can prove to be highly archival where as resin will yellow over time.

8.4 Resin for Preservation and Presentation

Artists have found various resins useful for preserving and coating prints and objects. Some painters even use layers of resin and paint to create incredibly dimensional paintings.

When approaching photographs with the use of resin, there are generally two reasons for its use. One reason is to preserve a print or material that might oxidize or change over time. The second is for coating. There are many concerns with preservation. Most people familiar with resins know that, over

time, some yellowing may occur. There might be problems with your art and its permanence. For example, tintypes are traditionally made with a tree resin, lavender oil, and alcohol. This has a yellow tint that adds to the warm coffee and cream tones of a tintype. Some artists are filtering varnishes to a near clear state because they prefer the clear, near-toneless finish on their plates. Age might alter these products and even the once clear varnish can yellow over time.

Artist Binh Danh made great examples of resin casting for the sake of preservation and presentation. As a disclaimer, the nature of resins change over time so there are issues with permanence to consider. Since resin yellows over time, Binh used black backing, knowing that white would show the yellowing of the resin. His previous bodies of work consisting of anthotypes, also known as chlorophyll prints on leaves, were preserved using the following methods.

A 1 inch thick or thicker acrylic sheet, cut to size, is used as the backing to position the art. It is framed in on the edges using peel and stick art/glass separator made by several companies including FrameTek Incorporated. He then sealed the corners and edges with masking tape to ensure that no resin leaked out onto the work surface.

The specific resin used by Binh is called EX-74 from a company called Tap Plastic and can be found online along with products from other companies. He poured a thin layer within his constructed acrylic sheet with spacers and allowed that to cure for an hour. He then dropped in his leaf print and let it cure fully overnight. The following day, more resin was poured on top, filling it up to the top of the spacers and letting it cure completely per the instructions of the resin. A third and fourth layer might be used depending on the thickness of the leaf or any object for that matter. The final step was to remove the self-made mold and frame the cured casting for presentation.

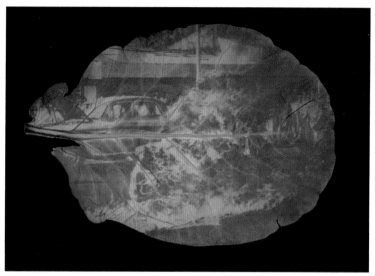

Figure 8.3 Binh Danh, *Self-Immolation of Thich Quang Duc* – from the *Immortality: The Remnants of the Vietnam and American War* series – chlorophyll print and resin

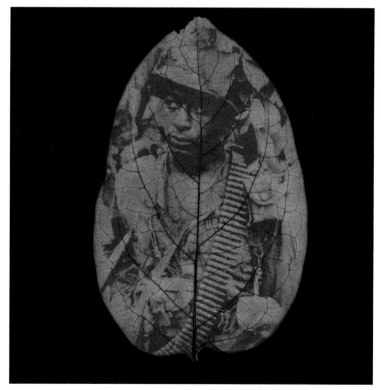

Figure 8.4 Binh Danh, *US Soldier* – from the *Immortality: The Remnants of the Vietnam and American War* series – chlorophyll print and resin

Another reason to use resin is to create a glass-like dimensional coating. This would usually consist of a single thin layer of resin over the surface, giving the print a finished glossy coating. When approaching either style, you will most likely need to create a framework so that you can pour your resin in layers and keep the edges tight and straight. The Resources section of this book provides information on products, companies, and stores where some materials can be found. Use your preferred web browser and search engine for quick and up-to-date results on anything you are searching for.

Additionally you may choose to allow the resin to drip over the sides for a different aesthetic. Whether you are using it in a controlled or loose fashion, use proper materials to protect your work surfaces from spills, drips, leaks, and otherwise.

NOTES

· ·

9

Installation, 3D Object Photography, and the Performance

9.1 3D Paper-Print-Based Sculptures

PAPER-BASED SCULPTURE

Paper-based sculptures have a long history in art. Papier-mâché is one of these very popular paper based processes. Essentially, you start with an armature or base of some kind, and you use any number of clear drying glues or pastes to apply paper layers to the armature. After building up your base, it is then painted or decorated.

The principles are similar when using it with photographs. You start with a preconceived idea of an armature shape, be it as simplistic as a cube or as complex as a human face. No matter which shape you choose, you may need to create an armature for rigidity; however, 3D paper-print sculptures can be created without a base.

After you have decided on your shape, you may either work intuitively with previously captured imagery and collage, or you might specifically photograph things to be applied with a clear intention. For example, if you choose to create a 3D sculpture of a face, you might actually photograph and print the various parts of a face to piece them together over the armature.

Before applying the actual paper print images, you might start by using your glue or paste with plain paper to build up the surface. If done this way, you can apply your images to the substrate/armature with little risk of damaging the print.

The shape and materials you use are really only limited to your imagination, but it is best to start simply in order to practice your working methods. Canvas, wood blocks, or even a blown-up balloon might be a good place to start. Paint a small area of your substrate with something like collage paste or white glue that dries clear. While wet, pick up a piece of paper previously torn into pieces and apply it to the wet glue area. Add more glue and more paper step by step until your substrate is covered in at least one layer of paper.

After drying, you can apply a second and third layer depending on the rigidity or thickness you desire. Using a hairdryer may reduce the drying time. Be careful not to use too much heat or you may damage your substrate or armature, depending on materials.

HEAT MANIPULATED PRINTS

Another form of 3D print-based sculpture is created through the use of mounting boards and heat. After mounting a print to specific materials such as PVC, you can heat, distort, and melt the substrate into different shapes or structures.

Jay Flynn uses a PVC board, heat gun, and safety equipment including a respirator. He heats up the mounted images, allowing him to bend and sculpt the imagery for very specific intentions. If you are going to attempt this method, note that some experimentation will be required. Depending on your print material, your substrate such as PVC, and the amount of heat will all affect the way you work and the outcome of the work. Start making art after you have defined successful working methods.

SPECIAL NOTE
.
Please use caution when working with heat sources and various other materials. Some products might produce harmful fumes, in which case a respirator and well-ventilated area will be required.

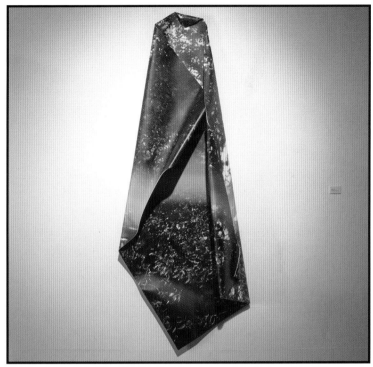

Figure 9.1 Jay Flynn, *Eidolon* – UV cured solvent ink print on Sintra (PVC) board: this image of the installation shows the result of his process using heat.

9.2 Photographs and Found Objects

Collage, assemblage, found object sculptures, and other similar art forms can be used with photography to emphasize a very specific visual style. Some artists rely solely on found objects, including found photographs as discussed previously in the sections on collage and appropriated art.

A great example of integrating photographs and found objects is from the unconventional work of David Emitt Adams. The following are examples of wet plate collodion positives on found objects from his *Conversations with History* series.

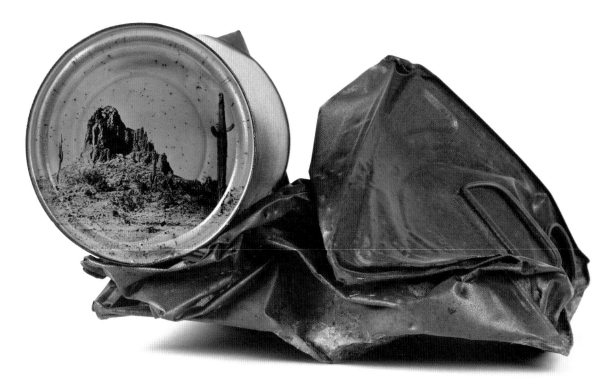

Figure 9.2a David Emitt Adams, *Getting Along* – wet plate collodion positive on found object

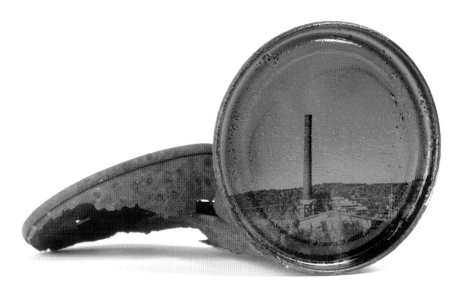

Figure 9.2b David Emitt Adams, *Smelter* – wet plate collodion positive on found object

Adams has also used 35mm canisters, disassembled and flattened, as an alternative substrate for wet plate collodion positives as seen in Figure 9.3. The inside of the canister is smooth and able to be coated in asphaltum, a process used to prepare the surface of tintypes, making them ready for use with wet plate collodion.

The work stands out as being unique, based on the process and materials, but the artwork is not only about being different. The film canisters are discarded from students and then used to make their portraits. It becomes a conversation, something more than a portrait on many levels. There is a relationship between mediums, between photography's history and the present, between the artist and his student subjects. Here are examples from his series, *36 Exposures* series.

An important principal to stick with when incorporating photography with found objects is to integrate them into something that couldn't exist on its own. If the artist relies solely on being different, there is a chance that the work wouldn't stand on its own to be intrinsically valuable. In other words, it may be perceived as a gimmick. Again, choose your process because your art can't look any other way. Refer back to Chapters 3 and 4 for beginning ideas in alternatives to substrates.

Earlier in the book we saw another great example of an artist using photography as an emphasis within found object and sculptural art, Beverly Rayner. Her work is built around photographic images, supporting, uplifting, and transforming the photographic work in various ways. She works with a number of processes including appropriated photographs, tintypes, daguerreotypes, digital color work, and a number of others to make her art. She further transforms the alternatives by using found objects, integrating other materials, and altering the images themselves through painting, cutting, and other hand manipulated alterations.

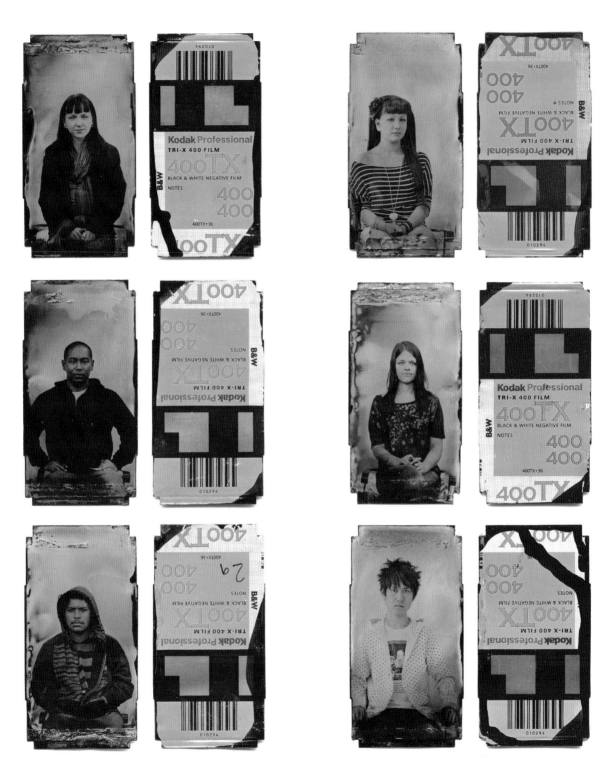

Figure 9.3 David Emitt Adams, *36 Exposures: Alexis, Yu, David, Sedona, Nicole, Chikara* – wet plate collodion positives on repurposed and treated 35mm film canisters previously used by students

Figure 9.4 Beverly Rayner, *Conjurer's Pot*

There are so many processes and variations within a single body of work that it is as though each piece she works on reveals what it needs in order to be complete. There is not a specific format or formula for her work.

9.3 Photographs and Installations

Photographs do not have to be presented traditionally in frames for exhibition. You may choose to use photographs as material for building a larger installation, be it a grid of

Figure 9.5 Deborah Winram, photo and object installation. Photo by Palma Brozzetti

images, a single piece made from multiple photographs, groups of reliquaries housing images sitting on shelves, or a complex and intricate environment for your photographs to be displayed.

9.4 Integrating Images Into 3D Objects and Sculptures

Some artists rely on the use of photographs in their sculptural art. As discussed previously, the photographs can become a feature of the sculpture and the other materials are a support. Either way, the various elements rely on each other to be complete or to speak of a larger narrative that they cannot accomplish on their own.

K.K. DePaul constructs wonderful sculptural-based photographic art pieces in various ways. The following are examples of how one artist might integrate photographs and other objects into a more sculptural and dimensional piece.

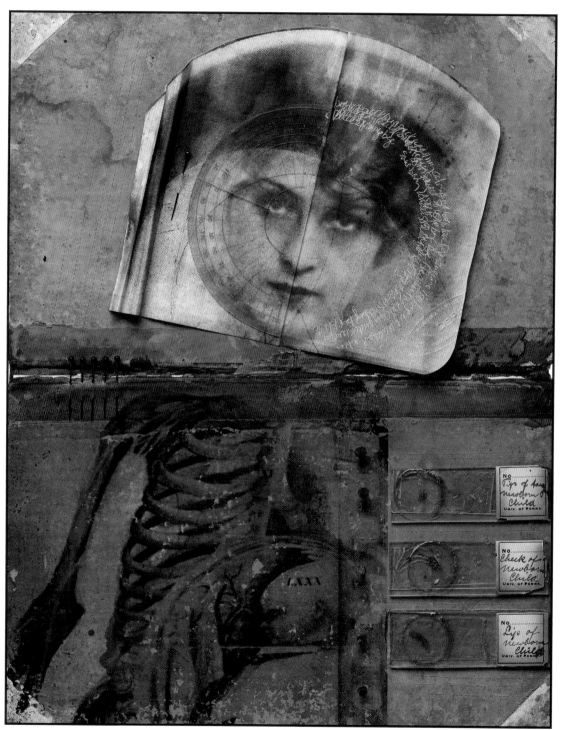

Figure 9.6 K.K. DePaul, *Barbara* – mixed media with Kallitype

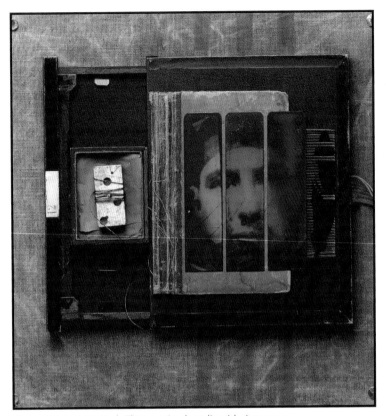

Figure 9.7 K.K. DePaul, *Three* – mixed media with tintypes

9.5 Performance Photography

Performance-based work doesn't need to be lost in the memories of those that viewed it. Make the performance permanent in a way no other medium can. This is where the artist and/or subjects are using photography to represent a performance or to illustrate a grand narrative. Some are finished as installations, or even displayed as slide shows through projected media.

As an example, I started this work with a self-portrait on a cellular phone, the phone is held in front of a pinhole camera with a Polaroid back. A 30-second exposure is made and developed and then that image is held in front of the pinhole

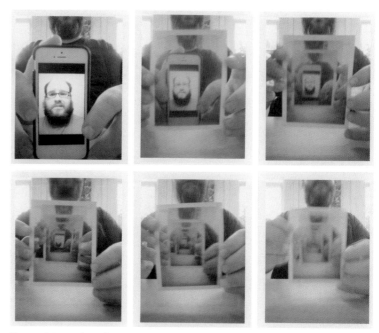

Figure 9.8 Brady Wilks, *Untitled* – performance art through photography, a commentary on the use of analog processes

camera to produce another. The second exposure is developed and then held again, repeating the actions several times until the original digital capture is fuzzy and unrecognizable. Here you see the performance step-by-step, ending with the finished piece.

CHAPTER 10

Alternatives to Finishing and Presentation

10.1 Print Finishing and Coatings

There are many ways to finish a print or take it a step further by manipulating its surface texture, sheen, or a number of other attributes. The following includes various alternative methods of finishing, framing, or presenting your work.

CLEAR COAT GLAZES

Traditionally, gel mediums have been used to extend paint, build up texture, or alter the finish of a surface. In Chapter 5, the gel is used as a skin or bonding agent. In this section, we will look at ways that acrylic gel can be used for different finishing techniques.

There is one characteristic of most gels and waxes that an artist should keep in mind. They all have a tendency to alter the color a little bit. Many matte finishes are the most noticeable, shifting the colors and whites into a warmer tone.

Using an acrylic gel and alternating the direction of brush strokes can create a canvas-like texture. Gel can further be built up to create added depth and dimension while maintaining transparency to reveal the image below. It can be used so

much as to entomb your artwork like an artist working with encaustic or resin.

ACRYLIC GEL FINISHING

Differences in Gel

Soft gels are thin and pourable mediums that range between gloss, semi-gloss, and matte finishes. This is a popular choice for top coating paintings. When using gloss, you can thin it further with a little water. Some brands suggest 2 parts gel and 1 part water. It's advisable only to thin gloss with water.

Regular gels are thicker and commonly used for transfers, glazes, and extending paint. Every artist will develop a preference when working with materials but regular gels are a common place to start, especially if you already have the material from another process.

Heavy gels are much like regular gels but tend to hold textures better, especially for those textures with sharper points and deeper relief. Even though these gels are heavy, they still dry translucent. There are even heavier gels available for things like impasto style techniques as well as most of what has already been described. There are other variations that include differences in shrinkage from drying, flexibility, brush-stroke retention, and a number of other characteristics.

Additionally, there are specialty gels for creating porous textured surfaces such as sandstone or stucco. Some specialty gels have glass beads and other additives for various textures as well.

Although most gels are UV resistant, there are specialty topcoat gels that have special ultraviolet light filters and stabilizers to protect a number of mediums from damage or fading caused by the sun.

APPLYING GEL: MATERIALS

.

- Acrylic gel matte medium for a matte finish or acrylic gel gloss heavy for thicker coats and a glossy finish
- Brush
- Paper towel and water for cleaning up

Using Gel as a Finishing Coat

Use enough gel to coat the surface of your image using the brush to distribute evenly. Once distributed evenly, use light brush strokes in a single direction, allowing the gel to dry between layers. Create a second layer and apply it using brush strokes in an alternate direction. Two coats might be enough for your chosen medium but 4 to 6 coats might be needed depending on your medium and aesthetic preference.

Building Up Texture with Gel and Paste

There are two main ways to deal with texture. First, creating texture on a substrate that an image may be applied to (relevant to Chapter 4 and substrate manipulation), or, second, creating a texture that dries clear on top of your imagery.

Gel and paste can be used when creating texture on a substrate, but most pastes don't dry clear due to material content such as marble dust. It is more likely you will reserve molding paste, fiber paste, or crackle paste for substrate manipulation and only use gel, which dries transparent, as topcoats. Only use the pastes or opaque gels should you choose to obscure parts of the image.

MATERIALS

- Small, microwave-safe glass dish (small plate)
- Fabric for applying wax, such as cotton flannel
- Lavender oil (use extreme caution with concentrated oils)
- Beeswax
- Knife

WAXED PRINT FINISHING

Some artists tend to have strong preferences between matte and glossy print finishes. If you prefer to have a shiny finish or prints with a subtle sheen, then waxing is a wonderful alternative for prints that are otherwise matte finish, such as salt prints on velvet fine art papers. It gives the surface a nice sheen and the tonality of the image shifts, slightly enriching it while protecting the print surface.

France Scully Osterman has used this technique and demonstrated it for me during a workshop in her studio. She uses the following materials for the application of the wax but

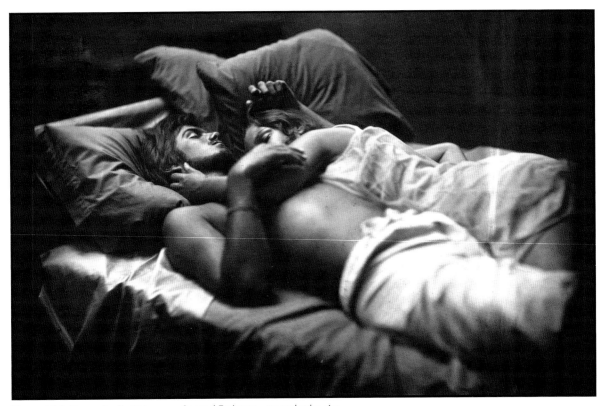

Figure 10.1 France Scully Osterman, *Second Embrace* – waxed salt print

you may find and work out your own methods for application. In the meantime, start with the following.

Place beeswax shavings into a microwave-safe dish, add a few drops of pure lavender oil and heat the wax, monitoring its progress so as not to overheat. Add more drops of oil as needed. Using the balled-up cotton flannel, incorporate the oil into the wax, moving in a circular motion. As the wax and oil are mixed, it will begin to build up in your cloth.

Place your print on a flat surface and tape down around all edges with masking tape. Gently rub the warm wax into the print. You may try small circular motions, picking up more wax and heating it up as you go along. Do not use too much oil and only enough wax to make an even sheen across the surface of

your print. Take your time and apply the wax evenly across the entire print. Wipe off excess with a clean lint-free cloth and you will have a beautiful print with an enriched tonality and lovely smell. Practice on small test sheets before trying a good print.

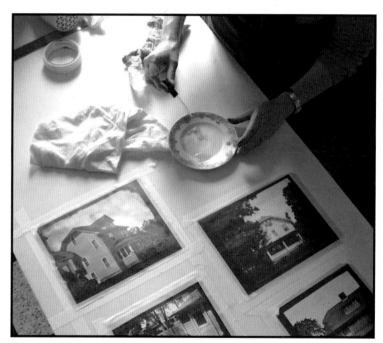

Figure 10.2 France Scully Osterman waxing salt prints

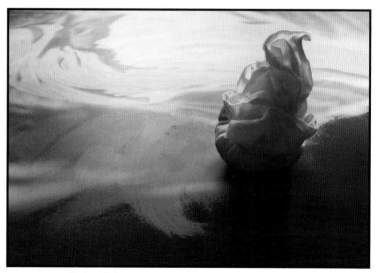

Figure 10.3 Cloth ball for wax application

Figure 10.4 France Scully Osterman, *Twisted Sheet* – waxed digital pigment print 36 × 48in

10.2 Framing

Framing is something often ignored and overlooked by artists until it is time to show the work. Artists in a rush might not have enough time to honestly evaluate the importance of their presentation format, leaving them with a standard or common frame.

FOUND FRAMES

Many exhibitions of traditional photography might frame work so that it is cohesive in design and style. Perhaps the work is all framed in a thin black metal frame and 3in over-mat. Other artists choose to use found frames, those purchased at yard sales or thrift stores. Still others choose antique or vintage frames from old work that is then upcycled or repurposed from paintings or other mediums. In this style, it is the variations that make the body of work unified. For example, the frames might all be warm toned but different shapes, sizes, moldings, and finishes. Together they work as a whole and individually they should support the work.

An artist might choose a frame to fit a specific piece of art, or the frame might reveal what kind of art should be displayed within it. This ties in to the possible need of altering a found or purchased frame. The frames might require some alterations.

ALTERED FRAMES

Burning

When working with old frames, altering them is a likely option to make sure they fit the styles you wish to work with. Burning or charring the surface of your frame can provide a distressed look, especially when in combination with sanding or other effects. When charring wood, a torch would be best for the sake of speed, control, and efficiency. An alcohol lamp or candle could work, but it would take an incredible amount of time compared to a torch.

Grinding

With the use of a power tool or other handheld tools such as grinders, sanders, files, and saws, you can grind patterns or make distress marks into the surface of the frame.

Paint and Distress

You may also use a combination of distressing and painting for more textures and patterns. Try distressing the surface before and after painting in various combinations. Try using framing samples or scrap pieces of wood that allow you to practice before altering the original frames.

Unconventional Shapes

Other sizes can be used as an alternative to popular aspect ratios such as 24 × 36, 16 × 20, 8 × 10, etc. The first alternative could simply be to use aspect ratios that are not 2:3 or 4:5 ratios. Elongated rectangles can be used horizontally or vertically for panoramic imagery or other aesthetics.

Circles and Ovals

Some frames come in curvilinear shapes, such as ovals and circles. Artists working in antique processes or aesthetics might use them with the opinion that they better support the imagery or style.

Much like any of the processes or choices, you are limited only by your imagination. Beyond traditional rectangles, squares, circles, or ovals, irregular straight edges and frame conglomerates can also be used. I must again stress the importance of making choices that support your work so that you don't risk the work being a gimmick or novelty on its own.

CONVENTIONAL FRAMES, UNCONVENTIONAL METHODS

Another great option is to use conventional frames in combination with imagery that has unconventional characteristics such as irregular image edges. An artist might cut an over-mat for a composited collage or for an image with irregular borders.

Figure 10.5 Dan Estabrook, *Fever*

Figure 10.6 & 10.7 Tom Persinger makes use of an arched window as seen in these two examples from his *Visions of a Poet's Love* series, titled *She must be dancing...* and *Through the Forest Green...* respectively

Figure 10.8 Jonah Calinawan makes use of irregular borders in his *Million Suns* series as seen here in his image titled *At Day's End*

MATERIALS SPECIFICALLY MADE FOR BOOK ARTS

· · · · · · · · · · · · · · · ·

- Book board
- Cover paper or linen
- PVA glue
- Glue brush
- Razor knife
- Bone folder
- Bullnose clamps
- Waxed or raw linen thread
- Screw hole punch
- and a number of other optional materials

An artist may choose to float their art in a way that adds dimension to the presentation. With use of a deep relief frame or shadow box, the artwork may be mounted in a way that it looks like it is floating. This may also be done without the use of a frame, directly floating the artwork onto a wall.

10.3 Handmade Portfolios and Presentation Boxes

One of the most popular and favored things to see in a portfolio review is a cleanly designed and assembled clamshell or drop spine box portfolio with a stack of matted photographs. There are a number of companies and artists who make these and provide custom portfolio and presentation box services.

There are a number of resources with instructions on how to make your own portfolio boxes or books. There are no specific instructions within this book on how to make various portfolios, but a common place to start is to first familiarize yourself with book arts and the materials associated with the genre. See left for a basic list of materials used.

With a simple search online, you will find great videos and resources on how to make your own book. I would also strongly suggest taking a book arts workshop. This book is obviously not an instructional how-to on basic book arts, so instead of going through the steps needed to make a box, we will review examples of portfolios and their alternatives. Remember, no matter what process you start with, you can find your own variations and methods. Start simple and evaluate the box's relationship to your work. Make sure it supports your art and does not overpower it.

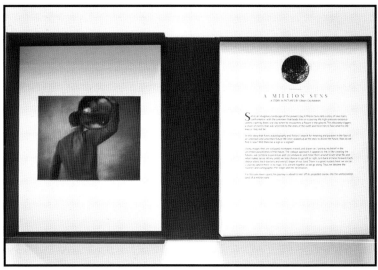

Figure 10.9 & 10.10 Jonah Calinawan had this portfolio custom-made for his body of work titled *A Million Suns*

WOODEN CASES

When working with alternative processes that result in 3-dimensional art objects, it is a good idea to think about presentation as well as storage. Brian Reda had a custom-made case that held custom-made frames of his wet plate collodion positive series. Finger slots, frame sizes, and other dimensions were all carefully considered so that this case could be opened easily and so that the multiple framed pieces could be taken out easily as well. When it is all packed up, there is little to no movement, making it a solid, shippable portfolio box that can be shared easily by mail or in person. It is a perfect blend of artful presentation and practicality.

J. Jason Lazarus has another example of a wooden case that was designed to match the content of the art and the aesthetic of the subject matter. He spent years photographing Alaskan mines and nearly forgotten places. He juxtaposes those compositions with photographs of historical artifacts and other depictions, painting a larger story. Furthermore, his portfolio presentation case matches that antique aesthetic not only of

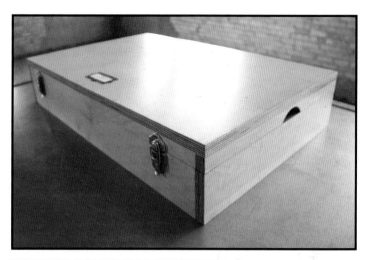

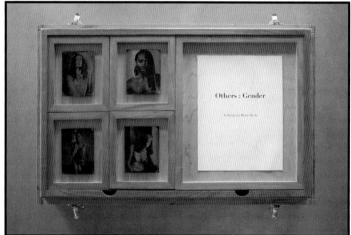

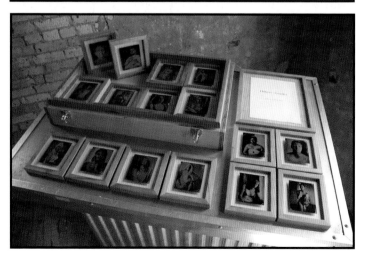

Figure 10.11 & 12 & 13 Brian Reda's custom-made wooden portfolio case with individually encased wet plate collodion positives

Figure 10.14 J. Jason Lazarus' custom portfolio case, matching the aesthetic of his prints and subject matter by use of distressed wood, aged leather, and burlap among other details

his Van Dyke brown paper prints, but the content of the subject as well. His wooden case was constructed in a way that matches the period, look, and style of the artwork. Wood, aged leather, and burlap flaps complete the presentation. It all fits with the aesthetic of the imagery acting as a supportive foundation.

SHIPPING PORTFOLIOS

There are companies that make and produce various portfolios with options for shipping. They are made to be reinforced and waterproof, with locks and clear pouches for shipping labels. They are made so that they do not have to be packed in a box. This kind of product might be reserved for someone working commercially or within the art for commerce market, seeing that their physical portfolios could be shared often.

BOOK PORTFOLIOS AND MONOGRAPHS

There is a trend in creating portfolios to be shared in book form much like a monograph. This is especially true with those

that make portfolios for shipping. Some people make books that also include an original print, mounted and incorporated into the design of the presentation box, with book and print revealed inside. Together they show the entire collection and how a print might look.

Some artists might think that scanning their images and making a book is enough, but with many alternative photographic processes, and even traditional prints in general, seeing an actual print in person is a different experience than a book of scans. There is a big distinction between seeing the rich cobalt blue of a cyanotype, or the texture of a fine art paper print as opposed to seeing a copy of an art object in a glossy book format. Making a portfolio that includes an original print or art object brings the experience of seeing the work in person and sometimes, in the case of tintypes or waxed prints, it brings the experience of smelling the work as well.

When thinking about making a portfolio in book form, there are three primary options. First, you could self-publish with a company that prints small orders or pay-as-you-go-style self-publishing. Second, you may hire an artist specializing in book arts to handcraft the books as long as you provide them with prints. This can be especially beneficial for those of you wanting to show original prints or offer special edition books. Third, you may take on the task yourself to learn book arts and craft your own portfolios in book form.

If you are looking for examples of amazing book designs, a great place to start would be by reviewing the books made by 21st Editions. They have made beautiful limited edition books for artists including Robert and Shana ParkeHarrison, Michael Kenna, Sally Mann, Vincent Serbin, Yamamoto Masao, Joel-Peter Witkin, and many other greats. Look through their collection to see great examples of what is possible in presentation regarding handcrafted book design.

10.4 Projection and Displays

Sharing or presenting your work isn't always through framed prints or portfolios. Through the use of projectors or displays, you may present your work as an illuminated projection or on a screen. An obvious example is presenting your work as a slide show or movie while giving a talk. The more conceptual ideas come with a greater narrative. Why use a projection? Perhaps you wish to display your work at a scale beyond your printable means. It may be that the work is supported by the context of illumination at night or you may be emphasizing a point to have everyone see your work as they would at home on their computers, even in an exhibit keeping the work digital for some specific artist intent. Again, you are limited only by your imagination and your resources.

10.5 Alternatives to Signatures

Some artists don't sign the front of their work, while others do. Some sign only the mat with the title, edition, signature, and date and perhaps include a label on the back of a mounted print indicating edition and year. Others working with certain surfaces are able to scratch their name revealing the substrate. There is a tendency for some of this to become a gimmick but the options are endless and here are a few unconventional options.

EMBOSSING

You may choose to add depth to your signature through the use of an embosser or embossing tools and stamps. Using these alters the physical dimension of the paper, creating a physical stamp as opposed to ink. A subtle signature or an embossed stamp of the artist's initials might offer a level of

authenticity, but it also adds more of a handmade aesthetic as well.

TRANSFER

You may choose to transfer a signature using acrylic gel or other method, incorporating that into your art while making the transfer or lift.

ENCAUSTIC, WAX, AND ENTOMBMENT

There is no reason your signature can't exist as an object itself in the corner of an encaustic, wax, or resin piece. Signing the print before coating it with your materials is only one level. Further the dimension by coating the print, then adding the signature and coating it again.

PAINT AND MARKER

It might be that your print or art object would look best with a signature in a particular color. Paint and markers will work differently for different mediums. An acrylic paint signature on an acrylic gel lift would be appropriate in regards to matching the mediums. You might consider using a signature like this before putting a final coat of gel on your print. Marker might work better for paper prints such as cyanotypes or Van Dyke browns, where you can match the color and find a cobalt blue or brown with a deeper value.

Remember many handmade prints are one of a kind and don't really warrant the need for edition numbers, however, if you are offering them as an edition, or disclosing that you will only be making a certain number of art objects with a specific image, then it might be important to include this kind of information on the back of your art object in the form of a label or something that won't damage the work.

Resources

ARTIST, STUDENT, AND TEACHER RESOURCES

The following information is a short list of various resources such as books, workshops, and organizations.

BOOKS, VIDEOS, AND WEBSITES ON HOW-TO, THEORY, AND ART

Jill Enfield's Guide to Photographic Alternative Processes by Jill Enfield

The Book of Alternative Photographic Processes by Christopher James

Black & White Photography: A Basic Manual Third Revised Edition by Henry Horenstein

Photographic Possibilities: The Expressive Use... by Robert Hirsch

Photography Beyond Technique: Essays from F295 edited by Tom Persinger

Transformational Imagemaking: Handmade Photography Since 1960 by Robert Hirsch

Primitive Photography: A Guide to Making Cameras... by Alan Greene

Basic Collodion Technique: Ambrotype & Tintype by France Scully Osterman and Mark Osterman

Experimental Photography Workbook 6th Edition by Christina Z. Anderson

The F295 Historic Process Workbook by Tom Persinger and F295

Surface Treatment Workshop 45 Mixed Media Techniques by
 Darlene Olivia McElroy
Alternative Photography – community website and instruction,
 www.alternativephotography.com
Analog Photography Users Group, www.apug.org
Luminous Lint: For Connoisseurs of Photography,
 www.luminous-lint.com
Anthropy Arts: Documentaries on artists such as Dan
 Estabrook, Henry Horenstein, Keith Carter and others,
 www.anthropyarts.com

MAGAZINE AND ONLINE PUBLICATIONS

Don't Take Pictures – biannual print, online magazine for
 modern photography, www.donttakepictures.com
Rfotofolio – a curated online gallery space for fine art
 photography, http://rfotofolio.org
Lenscratch – fine art photography daily, http://lenscratch.com
The Hand Magazine – publication for photography and
 printmaking, http://thehandmagazine.wordpress.com
Diffusion Magazine – unconventional fine art photography
 print annual, https://diffusionmag.com

WORKSHOP CENTERS AND PRIVATE TUTORIALS

There are plenty of workshop centers and instructors capable
of teaching various processes. This list is a good place to start
your search.

George Eastman House, Rochester, NY – historical and
 alternative photographic process workshops,
 http://eastmanhouse.org
Penland School of Crafts – photography, printmaking, and
 other workshops, www.penland.org

Center for Alternative Photography, New York, NY – Penumbra Foundation and CAP workshops, www.penumbrafoundation.org

Maine Media Workshops, Rockport, MD – photography and video workshops, www.mainemedia.edu

Anderson Ranch, photography, printmaking and other workshops, www.andersonranch.org

Sante Fe Workshops – photographic workshops, www.santafeworkshops.com

NewSpace Center for Photography, Portland, OR – photography workshops, http://newspacephoto.org

Many of the instructors associated with these workshop centers are also available for private tutorials, lectures, and other services, including Jill Enfield, Mark Osterman, France Scully Osterman, Tom Persinger, Brady Wilks, and many others.

MATERIALS

There are many manufacturers of cameras and associated equipment related to photography. The following are a few common resources for chemistry and other materials.

CHEMISTRY, KITS, AND ACCESSORIES

Bostick & Sullivan – supplier of materials and chemicals for alternative processes, www.bostick-sullivan.com

Artcraft Chemicals, www.artcraftchemicals.com

Chemsavers, www.chemsavers.com

Freestyle Photographic Supplies, www.freestylephoto.biz

Photographers' Formulary, http://stores.photoformulary.com

CAMERAS AND EQUIPMENT

Black Art Woodcraft – wet plate cameras and accessories,
 www.blackartwoodcraft.com
Guillory Cameras – wet plate cameras and accessories,
 www.guillorycameras.com
Zero Image – pinhole cameras, www.zeroimage.com
Pinhole Blender–pinhole cameras, www.pinholeblender.com
Lund Photographics – wet plate collodion accessories and
 materials, www.lundphotographics.com
Freestyle Photographic Supplies, www.freestylephoto.biz
In Camera Industries – plate holders,
 http://incameraindustries.com
Impossible Project – instant cameras and film,
 www.the-impossible-project.com

ORGANIZATIONS AND EVENTS

F295 and Symposium, www.f295.org
The Pacifica Chapter of the Center for Photographic History
 and Technology (CPHT) and Northwest Symposium for Alt.
 Processes, http://altphotopacifica.org
Alternative Photographic Process Symposium: Australia, in
 association with Ellie Young and Gold Street Studios,
 www.goldstreetstudios.com.au
Society for Photographic Educators (SPE) – Regional and
 National Conferences, www.spenational.org

Process List and Practicing Artists

The following is a list of various alternative photographic processes. It is by no means a complete list of every possible process and I do not have examples of contemporary artists for each category, even though I am sure there are plenty of great examples. With the examples that I have provided, and the included names of artists working in the process, a reader will be able to research and find some level of influence or inspiration. Search the web by process name or by the name of the artists currently using them.

ACRYLIC GEL LIFT/TRANSFER

Blue Mitchell
Kayleigh Montgomery
Brady Wilks

ALBUMEN

AMBROTYPE

Jody Ake
CitLali Fabián
Sally Mann
Mark Osterman

ANTHOTYPE

Malin Fabbri
Sarah Van Keuren

APPROPRIATION

BROMOIL AND OIL

Rebecca Sexton Larson
Emil Schildt
René Smets

CALOTYPE

Dan Estabrook
Luther Gerlach

CAMERALESS IMAGES

See Chemigrams and Photograms

CAMERAS AND MODS

Taiyo Onorato and Nico Kreb
Randy Smitt
Miroslav Tichy

CARBON TRANSFER

Jim Fitzgerald
Luther Gerlach
Borut Peterlin

CASEIN

Christina Z. Anderson

CHEMIGRAMS

Aspen Hochhalter
Anne Arden McDonald
Heather Oelklaus
S. Gayle Stevens

CHROMOSKEDASIC SABATTIER

Christina Z. Anderson

CHRYSOTYPE

COLLAGE

Sanne Griekspoor

COLLODION CHLORIDE PRINTING OUT PAPER

COLLOTYPE

CYANOTYPE

Jonah Calinawan
Jessica Ferguson
Emma Powell
Robert A. Schaefer Jr.

DAGEURREOTYPE

Binh Danh
Mike Robinson
Jerry Spagnoli

DASS TRANSFER

Bonny Lhotka
Ashley Whitt

DISTRESSED NEGATIVES

Christine Ann Verhoeven

DRY PLATE COLLODION

Nick Brandreth
Jim Sincock

EMBROIDERY

Julie Cockburn

Jose Romussi

EMULSION LIFT

See Polaroid Emulsion Lift

ENCAUSTIC

Christa Bowden

Stefani Frideres

Tina Maas

Kathryn Oliver

Clare O'Neill

FERROTYPE

See Tintype

FOLDED PRINTS

Alma Haser

GELATIN CHLORIDE

GELATIN EMULSION

GUM BICHROMATE

Christina Z. Anderson

Diana Bloomfield

Dan Estabrook

Brenton Hamilton

Dan Herrera

Kat Kiernan

GUMOILS

INSTALLATIONS

S. Gayle Stevens

KALLITYPE

John Metoyer

LIQUID EMULSION

Heather Oelklaus

LITH

Susan de Witt

LUMEN PRINTS

Barbara Dombach
Malin Fabbri
Sanne Griekspoor

METAL LEAFING

Dan Burkholder
Louviere + Vanessa

MORDANCAGE

Stacey Mayer
Elizabeth Opalenik

OPALOTYPE

Kaden Kratzer

PALLADIOTYPE

Kerik Kouklis
Peter Liepke
Bill Vaccaro

PANNOTYPES

PAPER NEGATIVES (INKJET)

PHOTO POLYMER GRAVURE

Trace Nichols
Jeanne Wells
Peter Wiklund

PHOTOGENIC DRAWING

Mark Osterman
France Scully Osterman
Carol Pannaro

PHOTOGRAMS

Adam Fuss
Martha Madigan
Nadezda Nikolova
Anne Arden McDonald

PHOTOGRAVURE

Fritz Liedtke
Kaden Kratzer
Unai San Martin

PHYSAUTOTYPE

Kaden Kratzer
Erin Mahoney

PINHOLE

Scott Speck
Peter Wiklund
DM Witman

PLATINUM/PALLADIUM

David Brommer
Elizabeth Siegfried

POLAROID

Emilie Lefellic

POLAROID EMULSION LIFT

Angela Kleiss

POLAROID TRANSFER

RELIEVO

Jay Flynn

SALT PRINT

Nick Brandreth
France Scully Osterman
Adam Finkelston

SOLVENT TRANSFERS

SUBSTRATES

TEMPERAPRINTS

TINTYPE

Anton Orlov

Mark Osterman
Jacqueline Webster

TRANSFERS

VAN DYKE BROWN

J. Jason Lazarus
Nadezda Nikolova

WET PLATE COLLODION ON GLASS/ NEGATIVES

Luther Gerlach
Borut peterlin

WET PLATE COLLODION POSITIVES

Willie Osterman
Joni Sternbach
S. Gayle Stevens
Alex Timmermans

WET PLATE COLLODION TRANSFER

See Pannotype

WOODBURYTYPES

Nicolai Klimaszewski

ZIATYPE

Colin Clarke
Jim Collum
Evan Stanfield

Index

Note: page references in *italics* refer to illustrations of photographers' work